Black-and-white photography

Black-and-white photography

John Wasley

Focal Press
London & Boston

Focal Press
An imprint of the Butterworth Group
Principal offices in London, Boston, Durban, Singapore,
Sydney, Toronto, Wellington

British Library Cataloguing in Publication Data

Wasley, J.
Black-and-white photography
1. Photography
I.Title
770′.28 TR146

ISBN 0-240-51117-4

First published 1983

Series designed by Diana Allen
Book designed by Hilary Norman
Cover photograph by Neville Newman
Photoset by Butterworths Litho Preparation Department
Origination by Adroit Photo Litho Ltd Birmingham
Printed in Great Britain by Robert Stace Ltd,
Tunbridge Wells, Kent

Contents

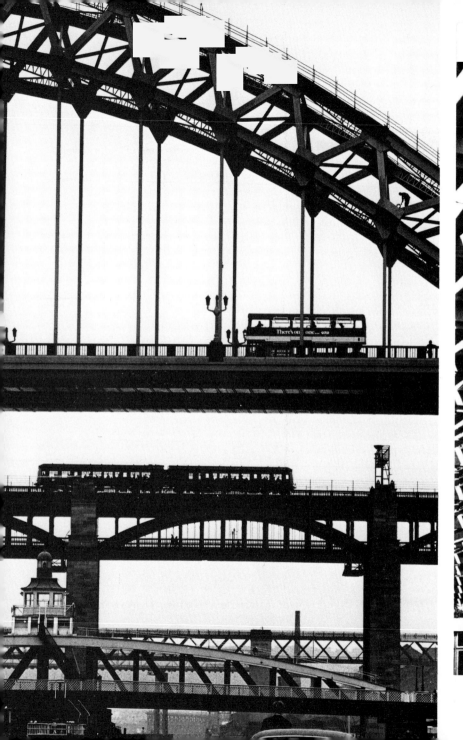

Introduction

In this age of colour, why black-and-white photography? It is a fair question, one which could be answered by a variety of stock answers, such as 'it gives a better impression of mood', or 'it reduces the scene to the basic elements, for a stronger composition', and so on. These arguments do not hold water. They are used to support the use of colour as often as black and white. What your photography does for you depends entirely on which medium you work in. So we are back to the original question, and no wiser.

The swing away from black-and-white began in the world of the snapshot. It is not difficult to see the reason. Compare snapshots in black and white with those in colour; the latter win every time. If mere pointing-and-shooting is your scene, it is easier to get pleasing colour than pleasing monochrome. After all, colour does look more natural than monochrome, and the colours do go a long way towards sorting out the jumbled mess that is the average snapshot. However, when the camera fan begins to advance his technique, things begin to change. (By the way, it should be understood that 'he' also implies 'she' throughout; the author is no chauvinist.) His first step is to make efforts to *think* about his pictures. As he concentrates on the scene, so underlying shapes, forms, lines, linear and subjective relationships of objects become in many ways more important than the subject matter itself. Thus, he takes these basic elements and creates his image by marshalling them into a special relationship with each other and with the subject. Gradually, as his eye gets keener, the chaos that once characterised his efforts is replaced by pictorial order.

Thinking in black and white

At this point a transformation takes place; monochrome and colour part company. They

ichael Dobson (left), *Raymond Lea* (above)

Ben Storm

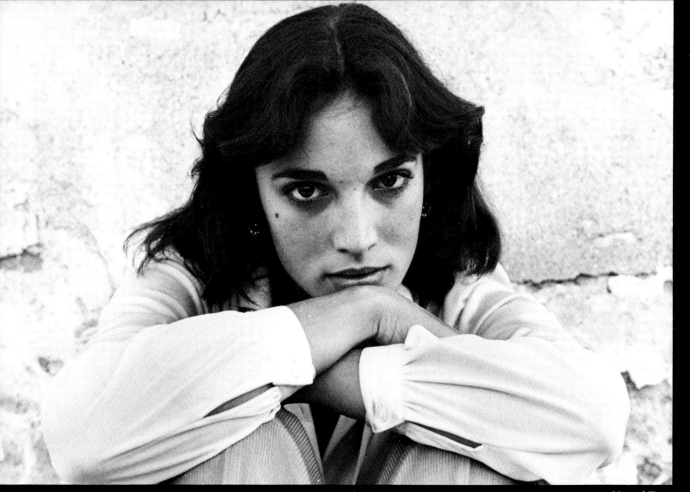

become two entities, jostling with one another for supremacy. When a thinking photographer uses one in preference to the other, he has to apply his mind to the one in use. When shooting in colour, he must arrange the hues as a part of the composition and create using this extra natural dimension. On monochrome film he has to reduce the scene visually to shades of grey and produce pleasing pictures in a somewhat unnatural medium.

Herein lies the challenge. The mind has to shift gear from natural vision to a special monochrome vision in order to see in greys only. This is no easy task. A photographer rarely achieves this by simply looking at the scene, particularly in the early stages. He must use painstaking, almost mechanical methods to visualise the image in shades of grey so that he can predict the way the image will appear on the print. After this, he must arrange those greys in such a way that they react with one another to produce the maximum effect. It is not easy, no matter what the confirmed colour worker may say. Enough of the comparisons. Suffice it to say that monochrome photography is not the poor relation of colour, nor a second-class citizen. It has a field all of its own; it is an entirely separate medium. It has its own idiosyncrasies, its own problems, its own challenges, and its own ways of meeting them. Do not get confused because you can use either type of film in the same camera. This is all they have in common. Beyond, the division is profound.

That monochrome is less expensive than colour is to its credit, particularly in these days of rising costs. But it is important to learn to use black and white for its own sake, not as a substitute for colour when you cannot afford it. Aim at making the most of monochrome, even deliberately using it for certain subjects and for special effects. Use it *positively* and you will be well on the road to achieving exciting, stimulating results.

The goal of black and white
The aim of any photographic process is to deliver a first-class reproduction. In monochrome photography, we shall refer to this end product as a Fine Print. The Fine Print is in a class of its own. It stands out; it sparkles; it is of such quality as to convert the colour enthusiast to black-and-white photography. Sadly, many photographers have never seen a Fine Print, and their ideas have been conditioned by prints which are less than excellent.

To begin with, a Fine Print has to be seen in the original. Copies or reproductions cannot do it justice or convey its impact. Therefore, if only to obtain an image of the standard to aim at (and certainly for inspiration) any time you have the opportunity to examine the original work of experts, take it! In the meantime, the aim of this book is to point you in that direction and encourage you along the rocky way towards achieving a Fine Print. The elements can be suggested quite simply, and if you follow them meticulously you will quickly produce your own first Fine Print. All you need is absolute control over exposure, development and printing.

'But wait', you protest, 'isn't that the basis of *all* picture-taking?' Certainly it is, but not in the way intended here. The idea is to start with your pre-visualised Fine Print *before* you press the shutter release. Then compose and assess the exposure that reflects your mental image. This, of course, requires a sound grounding in both exposure theory and practice. By understanding how light works and how it affects subject, meter and film, you are better placed to deal with luminance and colour, contrast and a host of other variables in terms of shades of grey. More important, you can use it to help you to see the image in monochrome, in advance. If it does not suit the mood you wish to convey, you can use this grounding to manipulate the greys to reflect the subjective values you foresee.

Processing is the bridging step. It responds to the exposure to produce precisely the negative you require. The correct methods and chemicals are determined by the exposure, and tempered by the

requirements of the paper on which your interpretation of the image will ultimately be printed.

In all of these stages, the only way to mould the image to your preconceived vision is to utilise your grounding in theory and practice. Working 'blind' by trial and error is to court disaster. The art of good black-and-white photography is to know exactly what to do, and what will happen at each stage. You must know not only how to take a picture, but also the precise effect any variation in procedure will have on the image. This knowledge is gained by experiencing the effect on your film, developer and printing paper of a wide variety of conditions. It is effected by appreciating that each successive stage should be handled, controlled and, if necessary, manipulated, to produce the required effect for the next step. Nothing can be treated alone. Appreciating this, what then is our goal? What is this Fine Print?

The Fine Print

A Fine Print must be *seen*. Words alone cannot give you the real picture. However, let us try to provide some of the basic points to look for; the rest is up to technique and a feel for the medium. A Fine Print is an image which does more than merely replicate the original scene. A simple record is not enough. In any case we are rarely able to transpose a scene onto paper literally, for both compositional and tonal reasons. Nevertheless, the Fine Print should have the full range of greys demanded by your pre-visualised image. Where detail is required in the important shadows and highlights it should be present, and the general tonal effect should be brilliant and with a special depth. In short, the print should be the best possible expression of the image you held in your mind's eye when you were at the scene. Moreover, every subsequent step you make after that point (exposure evaluation, processing, etc.) should be directed towards the achievement of that image, each stage making the closest approach to your pre-visualised ideal of which the camera is capable.

This, fundamentally, is our aim. In the comparatively short space of this book, some measure of the application necessary to obtain good black-and-white pictures will emerge. It is a challenge to be met, and its proper use is a skill to be acquired. I hope that some of my own enthusiasm for the medium will filter through the necessary lengthy explanations, at least sufficiently for you to make a serious attempt. That there are many time-consuming tests and experiments goes without saying. They are there to help you increase your knowledge about monochrome work; as you undertake them they can be exciting. However, they are only a foundation.

Do these tests. Don't allow the number of words needed to describe them put you off. As we said earlier, it is usually more difficult to describe something than to do it. The important thing is that when you have all the results of your tests you will know more about black-and-white film, exposure, processing, and printing than your photographically-inclined neighbour. And that knowledge will give you a greater confidence and practical skill than you ever had before.

The reasons for the need to develop the skills should be obvious. Confidence comes as a result of knowledge based on deeply ingrained groundwork. The philosophy is simple. Become fully familiar with the technicalities and make them a part of your habitual action, and then your conscious concentration will be freed for applying to the subject. This, of course, holds good whether you are shooting in colour or black and white. But, since the latter has inbuilt problems when it comes to depicting reality, technique becomes even more important. Once technique has become second nature, you have only to concentrate on composition, and on producing an aesthetically pleasing picture. Thus your confidence receives a boost. You *know* in advance that you will get a Fine Print. Together, you and your precision techniques will be able to create black-and-white pictures that really do you justice.

Frank Peeters

Black-and-white vision

The word 'expression' appeared in our attempt to describe a Fine Print. It is a word which goes some way towards helping to set monochrome pictures apart from colour. With the latter, the temptation is to produce nothing more than a realistic image of the original. With monochrome, however, the emphasis has to be different. We must invest the shades of grey with emotional values which share something of our inner experience, i.e. which enable us to *express* ourselves. In black and white, colours become less representational. The image is reduced to basic elements of shape, tone, line and texture. Inasmuch as they are now increased in importance, these elements have to be handled with precision.

As already suggested, black-and-white photography requires a specific approach. It is necessary to readjust vision to 'see' in monochrome. The reason for this is that colours that are quite individual in the scene can appear as uncomfortably similar shades of grey in the picture. For example, an orange flower against a blue background looks suitably contrasty in real life, but may be virtually the same tone when photographed in black and white. A straight colour picture may be bright, contrasty and full of impact; but the monochrome version shows the flower and background as grey and grey, hardly any variation at all. The result is flat and dull, and comparatively uninteresting.

The upshot is that a good subject for colour will not necessarily look good in black and white, and vice versa. A colour picture can depend on colour alone for its effect. A black-and-white picture cannot; it relies on tonal relationships and contrasts, and these are controlled largely by light and shade. We can play with tonal adjustments by manipulating the colour content of the light reaching the film

through filters, but the real impact is produced by emphasising highlights and shadows. We reposition the subject in relation to the light source, to inject visual excitement through contrast. Side-lighting or backlighting can produce this. However, it is fair to say that both of these methods will affect the entire subject, not just the different coloured parts. To modify those only, you must find another flower or background which will show up as a contrast in tones.

Visualising tones and shapes

At first, visualising in monochrome seems to be very difficult; the colours in the scene cling tenaciously, and our experience of (say) orange subjects maintains a mental image of the colour even when our eyes are closed. Perhaps the best introduction to 'monochrome thinking' is the use of a monochrome viewing filter. This is an olive-coloured filter which reduces the view of the scene to near-monochromatic tones, so that it is easier to assess the purely tonal relationships. A more precise method is described on pages 51–55. If nothing else, the filter drives home the importance of the need to develop a positive approach to tonal values in order to utilise them successfully. This means, first of all, getting away from the idea that tones are merely grey representations of colour; it should already be clear that 'seeing in colour' is a great hindrance. Recognise tonal values and their importance right at the beginning, then guide them into a special relationship with one another, in order to achieve the desired impact through the harmony or contrast of the tones.

Harmony is achieved by placing tones that are very close together in value next to one another, or even overlapping. Contrast means the placing of lights and darks close together. However, as you work at relating values to create an effect, you will discover that no shade of grey is absolute, but alters in appearance according to the nature of the neighbouring tones. Light tones appear lighter when set against darker tones, and vice versa. This is the crux of the matter; an understanding of this

trick of vision, and the deliberate application of the principles involved, provides you with a major compositional tool. During the course of this book we shall be discussing tonal relationships in some detail. Indeed, tones are essential in providing images of shapes in a picture. Every scene is composed of shapes of one sort or another, which not only define the subject and make it recognisable, but also go some way towards creating particular effects.

Try this experiment now. Look at the scene around you through half-closed eyes. Look at the general shape only; ignore the subject itself. Disassociate your mind from it; try to see an abstract image. Every subject is composed not just of one shape, but of several. There is the fundamental outline, but within that, there are other shapes all relating to the main one. This is how photographic subjects form a balanced whole. When it comes to turning a scene into a picture the relationship between the shapes becomes important. The collection of shapes forms part of the description of the object (the details complete the description); but if their interrelationship is merely random the result is no better than a snapshot.

To be able to recognise those shapes and marshal them into some sort of order, it is first necessary to see them in abstract form. Look at them not as parts of subjects but as elements in a picture. Take shapes and lines: verticals, horizontals, diagonals, all producing various angles, curves and flowing lines. Relate them specifically to each other, to the overall subject shape, and to the borders of the picture. These relationships must always be kept as simple as possible. Shapes which are disorganised or broken up loosely over the picture create confusion and conflict. Draw them together and organise them in a simple, rhythmically related area, and you have a unified image.

The reality of pictures

The principle of viewing in abstract is not a means of taking you away from reproducing truth. This

How real is a photograph? The photographer attempts to make his images look as real as possible but he is fighting a losing battle. The picture is a frozen instant in a continuum of time; it is two-dimensional; it is surrounded by borders; and, in this case, it is black and white. None of these things occurs in real life. Yet we are attuned to accepting these limitations willingly, and re-interpreting them in our mind's eye as reality.

Dominant lines in a picture help lead the eye to the centre of interest. They should be so arranged as to create patterns which stand up on their own and would create interest if deprived of the impact of the subject itself. Left: *Frank Peeters*. Right: *P. Chan*.

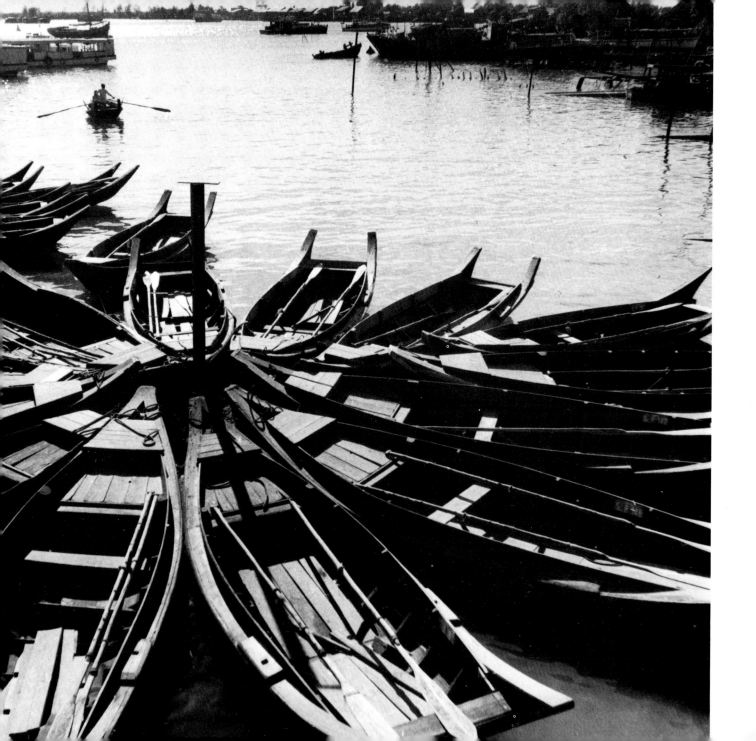

becomes evident when the unreal nature of a photograph is appreciated. Often, we strive for realism when in every sense it is impossible. So many things interfere: the picture borders, the lack of movement, the shades of grey in place of actual colours, and, perhaps most important of all, the lack of depth. A picture is two-dimensional, a flat image on paper or film. When reduced to two dimensions all the solid objects of reality, their lines, masses, shapes, tones, which in the original lie in different planes, become no more than patterns on paper.

Of course, when speaking of patterns we are not talking about the kind found on wallpapers. All these are designed to do is to break up a blank space as prettily as possible. To succeed, *picture* patterns must have unity and purpose. They should be designed to control the movement of the eye as it ranges over the image, and to communicate a message or evoke a mood. Such pattern-making is highly individual. Our thinking processes are moulded by our life's experiences and are unique to each one of us. Thus when we express ourselves in a picture we are putting in some of these unique responses to what we saw. This does not make photography anarchic. On the contrary, it endows the medium with a richness that gives interested parties untold pleasure. For underlying that individuality is a common root, a fundamental approach to putting down pictures on paper that has been with us over the centuries. It is a foundation language, if you like, as Latin is to the Romance tongues. Such are the 'rules' of composition.

Compositional lines

There is no set formula which can be applied successfully by everyone. Composition is not a mechanical process; it is a highly subjective art. Nevertheless, a few basic principles can be used to shed some light on the path. Apply them carefully at first and, later, when you have them firmly fixed at the back of your mind, you can re-examine them in relation to how you want to say things through

your pictures, and perhaps break them from time to time. In the meantime the goal is to produce patterns that would, if called upon to do so, stand up by themselves, without the added benefit of interesting subject matter to help them. To achieve this we must see beyond the subject to recognise the underlying pattern at the time of shooting.

It is not a simple matter to transform visually a scene from reality to a flat abstract. Even if we close one eye to reduce the impression of space we still retain the feeling of depth. In any case, real objects are still present to distract us. Seeing the image on a ground glass is a great help. The viewfinder of your camera is the nearest thing to it. Subjects are not reduced to abstract patterns, of course, but you get a fair impression of the appearance of the final picture. It has the added advantage of shrinking the scene to a smaller image surrounded by a border. After that it requires imagination. If we can mentally reduce the full colour, full-toned image to one which looks as if it has been printed on lith film – a line drawing or sketch if you prefer – the basic pattern becomes more evident.

Dominant lines

As we can expect, this basic pattern consists of lines delineating and defining shapes and moving in a variety of directions, but there is always a dominant direction. Let us revert to normality for a moment and consider the lines in a street scene. First, there will be those outlining the walls and other surfaces facing you, and moving across the plane. But if you are looking down the street the dominant lines will recede into the distance. They can be seen outlining walls and other surfaces of the buildings virtually at right angles to the line of vision. They also appear in the tops and bottoms of windows, the gutterings, the front door steps, the pavement edges, the road edges, and so on.

In a rolling landscape too, there are sinuous, flowing curves, almost like waves on a sea. Indeed, in any scene you encounter, in everything you want to photograph, you will find lines if you look for

Here curves are the dominant compositional lines, supported by strong diagonals and enlivened by the rhythmic pattern of the gear teeth. *Raymond Lea.*

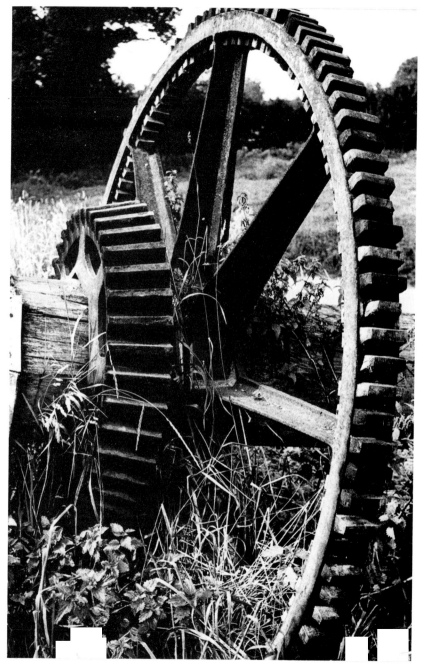

them. After a little practice they become quite easy to see. Often there are invisible 'lines' as well, which can be just as powerful. Consider a pointing finger, or eyes turned in a certain direction, or a speeding boat – all command us to move our eyes in the direction to which the subject is pointing. The pull is as strong as if there had been a line actually drawn in. We are enticed along by strong real and implied lines and guided by them towards the main emphasis, the object of real interest. Along the way, they draw the elements of the picture together and provide the means by which these elements interact to become a whole.

Strong lines have so much power that, if misplaced, they can lead the eye away from the subject and even out of the picture altogether. In those circumstances, your composition is lost. This problem is aggravated if the centre of interest is weak, even though you may have placed the lines immaculately. Unless it is obvious, there is nothing to say in which direction along the line the eye should travel. The direction of a line is ambiguous if seen by itself. However, if there is something of real interest on the line, or close to it, the eye will automatically travel towards it. Of course, in most scenes, there will be many such objects along the line. If they are all of the same importance, they vie for attention, so that the eye still does not know which way to travel, and is merely confused.

In every picture there should be a single object of greater interest than any of the others. As far as possible all lines should lead to that one. We are psychologically attuned to it, and our eye will move along the carefully-composed lines, from areas of lesser interest to objects of greater interest. But even with an excellent subject, conflicts can be set up when very strong lines lead through the borders of the picture. Edges are a powerful attraction; corners even more so. Lines passing out of the picture through them will carry your eye out as inexorably as a magnet.

19

Lines which express feelings

Near the beginning of this chapter we touched on the need to hold the eye of the viewer long enough to get across the message and the feeling conveyed by the picture. Lines can be used to express and amplify both of these requirements. Emotion is primarily shown by the type of lines, or line shapes present. We are disturbed by abrupt, jagged lines; we feel dignity and even majesty evoked by soaring verticals; or are enlivened by the agitated activity of diagonals; or are soothed by the graceful flow of curves. Lines are usually governed by the choice of subject. A sedate Gothic church, for instance, possesses dominant verticals and has an inbuilt aura of dignity. To ensure the capture of this feeling in our pictures, we must make full use of verticals. It is how we use them that matters, how we handle the lines when we create patterns on paper.

Leave nothing to chance when working out the composition of a photograph. Even a shot of a beautiful church should be a personal expression. Your creative act is born in your interpretation of what you see, not simply in recording it. You express your personal feelings with the patterns you make. If there were one rule for achieving this, it would be 'keep it simple'.

Perhaps, by analysing the attitudes to, and uses made of, lines, we will be able to see more clearly how best we can use them. Line patterns are not easy to apply, because during the course of shooting a picture there always seem to be other things on our minds. Yet pictures can often be vastly improved just by a slight change of viewpoint. Seeing this possibility only on the final print is too late. The key is to take time. There is no real hurry unless you are dealing with some sort of action; even then it pays to take time over the selection of a good viewpoint, before the action begins. Try to visualise the scene in abstract form on a flat plane, and arrange the shapes and lines into a meaningful pattern. Take charge of the subject, even an inanimate one; do not allow yourself to be dictated to by it. Impose your own feelings on it.

Space lines

It may seem perverse that, after spending so much time on the importance of seeing the original image on a flat plane, we should begin to look at it in terms of space and depth. But we are in the illusion business, that is the business of making people believe space and depth exists on the two-dimensional piece of paper they are holding.

The first step is a fully-ordered pattern. Anything less, and space will not be explained properly. The jumble of lines will be no better than the scribbles of an 18-month-old child. Start by thinking of your camera as an extension of your eye. When the eye sees a familiar frame of reference, it can be fooled easily. For instance, space is most readily understood from a highish viewpoint; eye-level is just right. We see things as we normally do and we get our directions correct. The front of the scene is at the bottom of the picture, and the back of the scene is at the top. Couple this with diagonals, or curving lines which converge and diminish in size (i.e. impressions of perspective), and the illusion is complete.

However, it must be controlled. Space can easily get out of hand and suggest too much or too little. In the former case it creates a sort of vacuum in your picture, the eye being led nowhere in particular; in the latter the picture is too flat. It is possible to control space which would otherwise run away with you by counteracting the direction of movement by lines which essentially lie on the surface of the paper. These are verticals, horizontals, and opposing diagonals. To stretch a flat image, you must hide or eliminate these space-stopping lines.

Action lines

When you see an object that in the normal way would be vertical leaning over at an angle, it

Opposing diagonals prevent the perspective of a picture becoming too overpowering.

20

appears to be falling, even though it may be frozen in a photograph. This gives us our first meaningful *action line*. A diagonal has the additional function of suggesting image movement. We recognise this in pictures of sprinters, falling trees and other tall objects, and so on. In all of these there is a certain instability. This is natural enough, but it can be brought to rest and strengthened by an opposing diagonal. However, since action is our aim, we will hardly *want* to stabilise it.

The difference between an action diagonal and a space diagonal is one of direction. The former tends to lie parallel to the picture surface. It can recede into space a little but, if it goes too far, then it becomes a line which interprets depth. Where the diagonal is shown in a series of angles, or in jagged lines, it depicts a kind of volatile strength or even danger.

Horizontal lines, and in some cases verticals, can also be used to suggest movement. Think of racing cars, racehorses, athletes. Their direction of movement is horizontal, and their slipstream is suggested by horizontals. A similar effect occurs in the vertical, with, for example, free-fall parachutists, high-divers, pole-vaulters and so on. Indeed, in high-speed action where blur is deliberately used in the picture, horizontals and verticals are clearly visible, oriented in the direction of movement. Some objects suggest speed even when standing still, for example, racing cars and jet aircraft. Other means of suggesting action are repeated shapes, and repeated lines, as where one curve flows into another.

Static verticals and horizontals
These are dealt with together because their uses (and problems) are similar, even though they are, as it were, opposites. Lines which stand erect have stability, and transmit a feeling of dignity. Where the subject itself does not demonstrate such things, a vertical format supports the impression.

Verticals are true pattern lines. They have the effect of flattening space and positioning the image at the surface of the paper. Because they repeat two sides of the picture frame, you can use any number of them effectively and harmoniously. Indeed, a sequence of verticals could suggest continuous direction and pull the eye from one to the other onwards to the centre of interest. However, beware of too much order in pattern compositions. The result can easily be mere boredom. Such patterns need variety. The simplest way to introduce this is to include lines at right angles (in this case horizontals) here and there. Tension, and consequent interest, is created. This also has the effect of retaining the verticals within the frame of the picture. As with all other lines, if our verticals are unopposed they will lead the eye right out of the picture. Secondary horizontals contain them and halt the eye movement.

A similar effect is achieved when you use vertical accents on an image dominated by horizontal lines. These too, run parallel to two sides of the picture frame and it is possible to include a number in your composition without losing the unity. Even with accented verticals the mood of quiet restfulness and calm will remain, evoked by the dominant horizontals.

Rhythmic lines

Rhythm can be found wherever there is a repeated pattern. A row of verticals, horizontals, diagonals, or similar shapes can be said to be rhythmic. But we are concerned here with another kind of rhythm, that found in the graceful, fluid curve. This is the most potent element of composition. A curve can suggest harmony, unity, continuity, motion; it can be happy or sad. It forms patterns if photographed parallel to the surface of the picture, and expresses space if it recedes into the distance. A curve can also be made to relate to another to form a sinuous line for a peaceful, although not necessarily quiet, flowing motion. When closed in a circle, it suggests motion continually coming back on itself, and focuses attention on a single point.

The dominant verticals of the church produce an impression of dignity. They are prevented from carrying the eye out of the picture by the secondary horizontals of the steps and gate. These add an element of interest and help to lead the eye back to where it belongs, on the church.

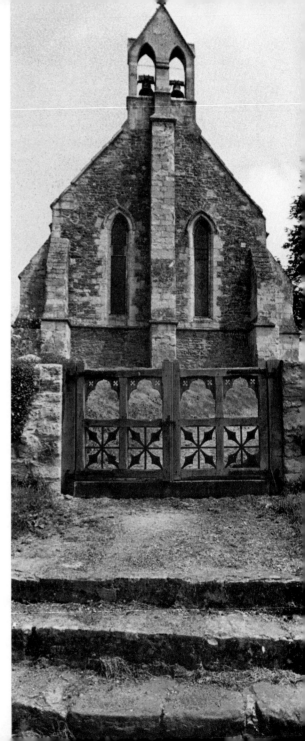

Far right: a continuous curve on its own is not really strong enough. It needs the sterner stuff of diagonals, horizontals, and especially verticals. In this picture the curve of the staircase is strengthened by the central vertical pole and by the people. Moreover, the continuous line of people all travelling in one direction helps to carry the eye round the spiral to the top.

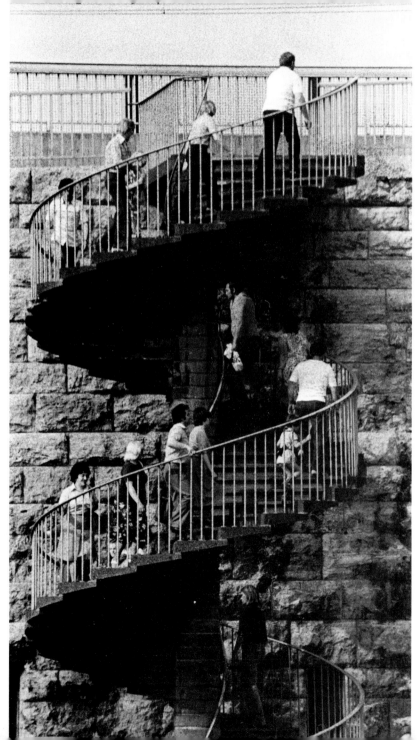

However, circles are best shown with breaks. The old enemy, monotony, can encroach on an enclosed cyclic composition; breaks provide the necessary variation while still implying a continuous design. When interrelated in this way, curves have their own special kind of rhythm. Although the eye will follow curves to wherever you want it to go, there is an integral weakness built into composition containing only curves; they lack strength and to some extent power. Straight lines counteract this. They give compositions the necessary strength by providing eye-catching contrasts and variations.

Unlike horizontals and verticals, curves do not match the picture sides at all. Indeed, they appear distorted if too close to the edges. Keep them away, and above all, don't let them wind their way in and out of the picture through the sides of the frame, or the eye will simply follow them out. In another way, curves can express totally undesirable emotions. Should you choose a viewpoint where a graceful curve is shown as only a slight bend or curvature, especially where many lines flow in different directions, the image will appear indecisive and weak.

On the other hand, if there is a series of curves, all leaning the same way, they will suggest movement in that direction, for example tall corn swaying in the breeze. The greater the curvature, the greater will be the impression of movement. Planning is the keyword for such compositional control. It may be slow going at first, but if you practise using these visual skills with dedication, you will soon find them becoming second nature. You can derive a certain amount of help from studying your failures; but the real issue is to learn to visualise in tone, line and pattern form before you finalise a viewpoint. The effectiveness of your monochrome pictures will prove the value of the effort.

The flowing curves of the wings, and the obvious direction of flight, help to pull the eye along in a specified direction; the pull is as strong as any real lines. *Michael Dobson.*

Repeated shapes add an impression of movement to any picture, even when the subject is relatively static. *P. Chan.*

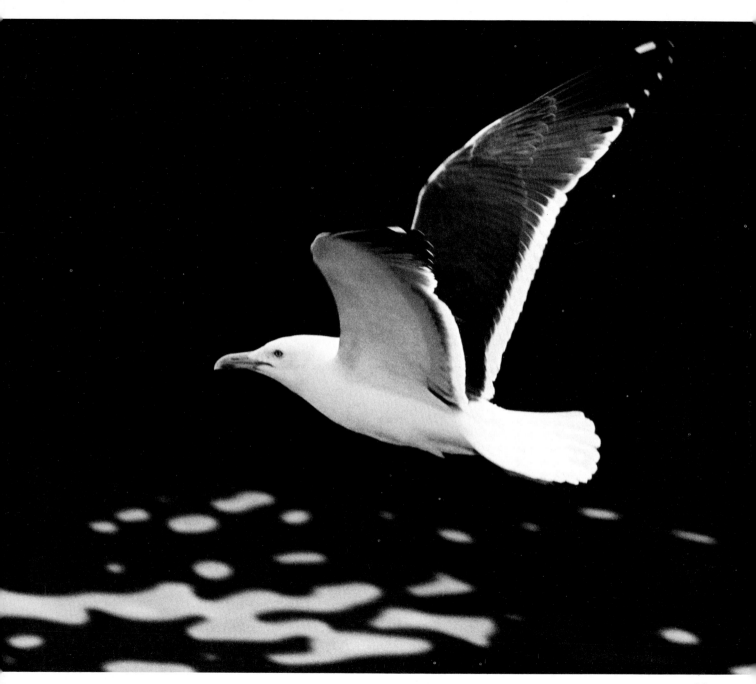

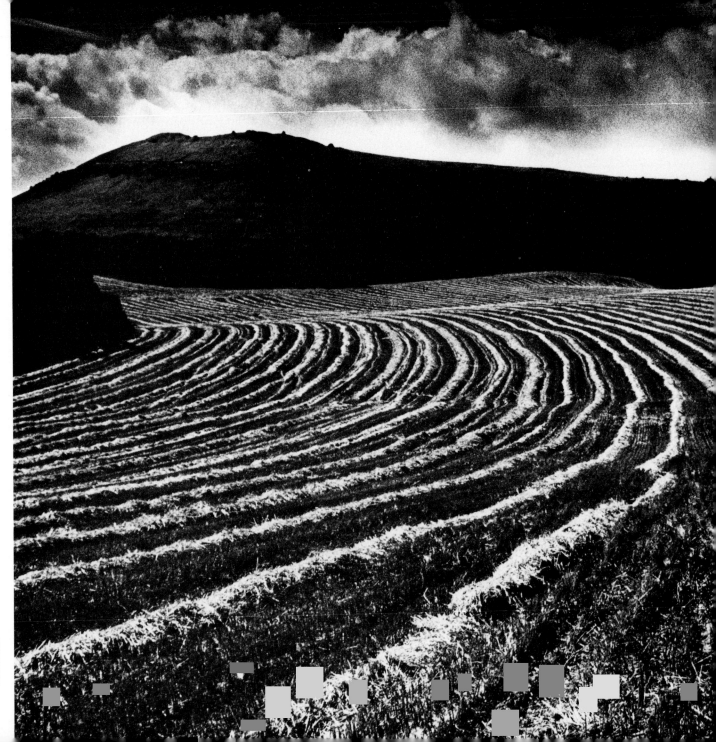

Ben Storm

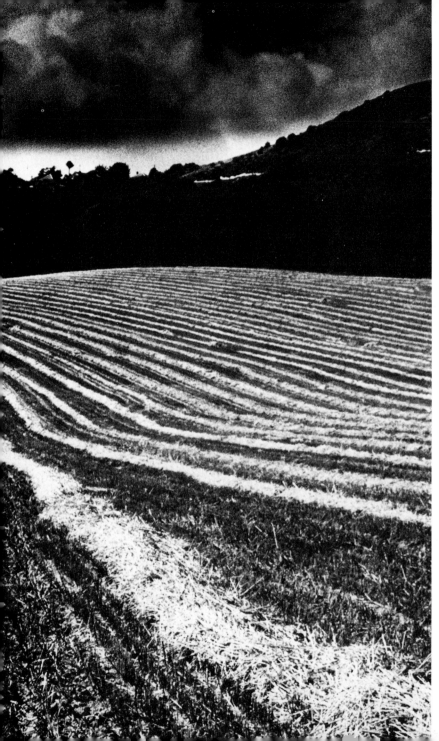

Light and the subject

Light is the life-blood of all photography, but one of the issues which sets monochrome apart from colour is that it is dependent largely on light and shade to produce its own individual effect. Colour can manage with hardly any shadows, relying on the relationship of colours. The problem is that we take light for granted. It is there, and we use it as a means of taking pictures. As long as there is sufficient light to affect the emulsion, and as long as the level is determined correctly, we can be assured of getting a correctly exposed photograph. However, the use of light goes a little deeper than this. The quality and direction of light make the picture, and the real answer to effective light-painting lies in understanding (a) its effects, (b) what it does to the subject, (c) how the film responds to it, and (d) how you can use it to capture the precise image you have in mind.

The content of light

The best starting point is to learn to appreciate the properties of light. White light is composed of a range of wavelengths, each of which, when seen separately, appears as a particular hue. With increasing wavelength the spectrum runs from violet, through blue, blue-green, green, yellow and orange, to red. Where light falls on objects it may be partially absorbed and partially reflected. Objects which absorb (say) most of the reds and blues reflect mainly green, and so appear to us to be green. That is how we see colours; it is also the way a film responds to them.

So-called white light is difficult to define. Its content varies according to the type of source. For example, household lamps have a high red content, whereas the sun, in combination with skylight, has a high blue content. When the sun is rising or setting, the extra atmosphere layers through which it must pass tend to lower the blue content of the

sunlight. These changes in content (or *colour temperature*) do not greatly affect monochrome film, though one type of emulsion may have greater sensitivity to the red end of the spectrum than another, and therefore be more sensitive to tungsten lighting.

The quality of light

Quality of light is important to black-and-white work in the relationships between light and shade. A harsh, strongly directional light casts hard shadows with very sharp edges; in a photograph these come out deep black, with no detail. A diffuse light softens these edges.

There are two factors which influence the light. One is the light source itself. Strongly directional light comes, for example, from a spotlight, or unrelieved desert sun. This means that the photographer often needs a supplementary light source (or a reflector) to lighten the shadows without changing their character. More details are given later. Light is softened by dispersing the light with diffusers, e.g. translucent material in front of the spot, or light cloud covering the sun. In both cases, directional light is then scattered in different directions, some of it into the shadows. The second factor is distance. This, of course, does not apply to sunlight, as our distance from the sun does not vary appreciably. With artificial light sources such as studio lighting, flash etc., the quality of the light changes as the subject is moved farther from the source. This also happens when the source is light from a window.

In these two areas we have the basic tools for personal expression; diffuse lighting can suggest gentleness and softness, while directional lighting can create moods of anger, danger, discomfort and starkness. Of course, there is a whole range between these extremes. There is, too, shadowless lighting. Each picture calls for just the right quality and tonal balance. Once you have chosen your light source, then, you must decide on the direction of the light.

Directing the light

Lighting direction can produce the all-important impression of depth in the flat print. This comes from the relationship between light and shade. Light by itself reveals shape; shadows combined with light reveal form. When the light source is directly in front of the subject, the shadow falls directly behind the subject, and is invisible. The subject, whatever its shape and form, appears to be flat, virtually a two-dimensional cut-out. With two eyes you may be able to discern depth without the help of light and shade in an actual situation; but on a photograph, where three-dimensional space no longer exists, it is another matter.

Move the light, and the entire picture changes. A cube-shaped object, for instance, looks cubical when one or two of its surfaces are bathed in light, leaving the others sunk in shadow. This is so whether the cube is viewed in real life or in a flat picture. The edge between light and shade tells you its form. The shadow makes the cube look like a

This carved wooden panel was dramatically sidelit by shining a torch obliquely across it. *Raymond Lea.*

cube; more important, the suggestion of depth is strong. On a cylindrical or spherical object, this lighting direction reveals its form in a more subtle way. The light appears to blend into shadow over a distance. The shape is clear, and the image conveys a strong illusion of depth. All this is possible simply by moving the light away to one side. This is fine, of course, if the light (or the subject) is movable. Where a sunlit subject is immovable, you must exercise patience. The sun moves (all too slowly) across the sky, and you must play a waiting game until everything is right.

Lighting tends to look most natural when it emanates from between 45° and 60° above, and about 45° to one side of, the line of sight. This is the sort of lighting produced when the sun is somewhere overhead during mid-morning, or mid-afternoon. Even when you use complicated lighting set-ups for studio work, you should start with your main light in that position, as your substitute sun. Choose the type of lighting you need to create the desired mood. A spotlight provides sharp directed lighting, with contrasty shadows; a flood, perhaps diffused, softens the appearance. Whichever you choose, it is this 'key' light which provides the form-revealing or 'modelling' illumination.

Set up the other lights to achieve one of two effects: (1) to lighten, or fill in, shadows; (2) to provide special highlight effects on the subject or background. Both, you will notice, are effects supplementary to that produced by the main light. Secondary illumination for lightening shadows should be soft (diffused) and positioned at such an angle and distance that it throws no noticeable shadows. This means that it needs to come from a position close to the camera axis. Highlights, on the other hand, need to be strong and concentrated. Suitable sources are spotlights, lamps which project a narrow beam. Shadows from such lamps should fall outside the picture area; with this proviso the light must be placed where it will deliver the required effect.

Light reveals shape, shadows reveal form. Here, the relationship between shadow and highlight emphasises the three-dimensional quality of the subject. Abrupt changes from light to dark define an object as cubic or angular. Without the shadow, this would not be easy to discern on a flat piece of paper. Likewise, a slow, gentle transition from light to shadow reveals a curved shape.

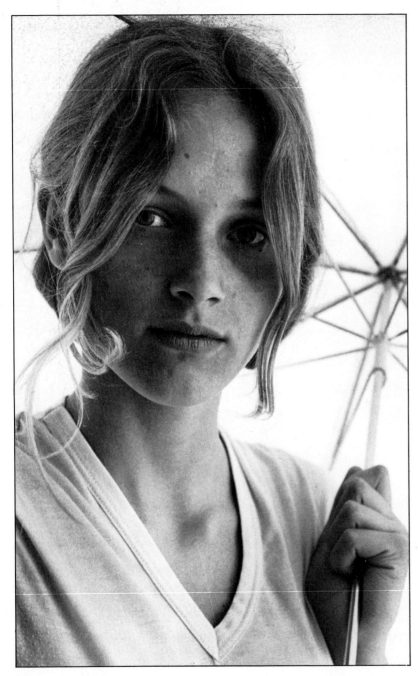

Left: diffused lighting, with the help of the pale brolly, has softened the shadows and reduced contrast in this portrait. *Manuel Torre*.

Right: the photographer has used the strongly directional light in this scene to evoke a calm evening mood. *Ben Storm*.

Side-lighting

Real excitement can be generated when we deviate from the norm. For special effects, we can play around with the lighting direction. When the subject is illuminated from the side, the light-and-shadow relationship is exaggerated, and the effect of solidity is dramatic. The subject appears stark and dynamic, and very much three-dimensional. Such extreme side-lighting reveals not only overall form, but also texture. Undulations, pits, projections and surface texture of the object are caught by the light and are emphasised. Surface texture, thrown into relief, adds a new dimension to the illusion of reality. The visual sensation is such that the viewer experiences the 'feel' of that surface and may be almost prompted to reach out and touch it. This makes your illusion act complete: although the image is only two-dimensional, it *looks* real. The features of the human face can also show texture. Sidelighting will reveal the wrinkles and pores of the skin with cruel accuracy. So, unless you particularly want this effect (or want to lose your friends) don't use this technique in portraiture.

Low-angle lighting

A light positioned lower than we normally feel is acceptable produces dramatic effects. Consider the long shadows prevalent around sunrise and sunset; peace vies with menace. Remember the Dracula movies? Evil personified in the 'fanged one' as his victim's blood oozes out of the corner of his mouth, almost dripping into the light source! The hair rises on the backs of our necks, and we shift about in our seats. Perhaps *our* pictures will not elicit such a

Side-lighting reveals the tactile qualities of the subject. This adds a new dimension of reality to the image. Where the surface texture is strong, we could almost reach out to touch it.
Raymond Lea.

A light held low to illuminate the subject can add a sense of foreboding and even evil to a picture. This gentle cat has been turned into a nightmare figure by the low angled lighting. Such lighting should be used only for special effects.

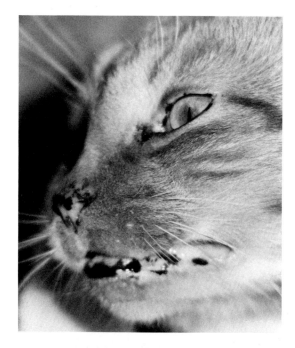

response; in any event, unless you are sending up a friend, a light shining straight up his or her nose is not likely to elicit co-operation. Nevertheless, you can occasionally use a low light to express a feeling, or to turn an action into something different. Look, for instance, at the picture of the cat accompanying this chapter. It seems to generate evil. Yet he is a very gentle animal, thoroughly good-natured, who just happened to be scratching himself when he was photographed close up, with an electronic flash at a low angle. Who says the camera doesn't lie?

Backlighting
When light falls on the subject from behind, the part of the subject facing the camera is in shadow. Recorded as a silhouette, there is still a remarkable impression of depth. The reason is a little more subtle than with side-lighting. Dark tones are translated by the eye and brain as projecting, or thrusting forward. Light tones, conversely, are seen as receding into the background. Thus the illusion is that the darker subject stands out from the lighter background. With the subject as a silhouette, the separation of distances is heightened by extremes of tonal contrast, emphasised still more by the rim of highlight round the subject. The forcefulness is achieved by starkness of contrast and the clear delineation of the outlined shape.

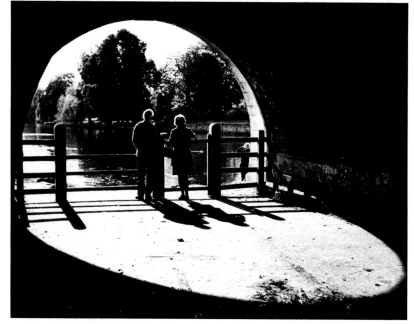

Backlighting must be controlled carefully to achieve the effect you desire. It is tricky, and can cause flare and misleading exposure measurements. If you want detail in the subject, make sure you read only the subject and exclude any other light from the cell. Then adjust your aperture for the value you require. *Raymond Lea.*

When detail is put in the subject, the lighter-toned background is pushed right up the scale into overexposure, and produces a high-key result. Surprisingly, though, the effect you sought to achieve with a silhouette is still present. The burnt-out highlights, appearing in the final print as stark white, achieve separation and depth. The effect overall is light and ethereal. Rim or halo light effects are less harsh and merge with the bright background. Light and shadow, then, are the driving forces for black-and-white pictures. The contrasts make the images; they capture and hold the attention of the viewer.

Handling contrast

Since much photography is practised under bright sunlight, dealing with excessive contrast becomes a problem. It is true that monochrome film needs contrast to create its effect, but too much will spoil this. Empty, solid shadows and bleached-out highlights produce an unsightly soot-and-whitewash effect which is pictorially worthless. A great deal of afterwork is required to produce an image of anywhere near the quality needed to produce a Fine Print. If you can control the contrast at source, the problem is solved. One method has already been mentioned in the previous chapter, namely placing some distance between the light source and the subject. Here are twelve more:

1 Wait until the light is softer. When the sun is hazy or has set, contrast is greatly reduced. Naturally, you can only play a waiting game when the subject is static. However, it is one of the simplest ways of reducing contrast.

2 Find some shade. An easy answer to high contrast is to get a movable subject out of the bright light. Simply move to a shaded area and use the softer light to produce less harsh results.

3 Fill in the shadows. If you can brighten the shadows and thus lessen the difference between shadows and highlights, the contrast is lessened. The difference should be about two stops, three at

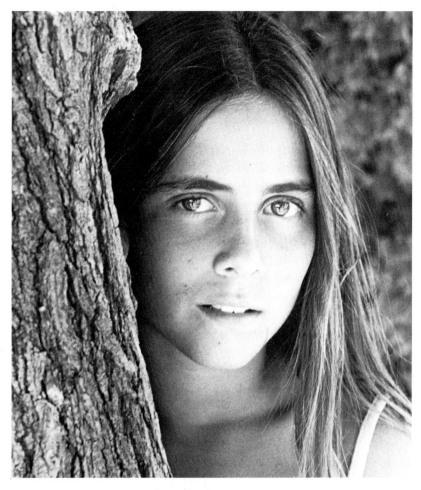

the most. Your meter will tell you how much filling in you have to do. The most common method is to use a reflector. A newspaper, white or light-coloured material, even white clothing you may be wearing, are sufficient to throw some of the light into the shadows. If you are in a studio, you can use a second light source or a reflector. Here you have full control; you can see the effect before you shoot. It is a different story with flash, a popular method of brightening shadows. Success depends entirely on how well you know your flash equipment. Test it thoroughly both indoors and out, so that you can produce precise light levels at any time and under any conditions. Take a reading of the subject in the normal way, basing your exposure on a shutter speed which will synchronise with your flash. Use the aperture given to base your calculations for the flash-to-subject distance. However, this gives you a 1:1 lighting ratio, which is too flat. You need 1:4 at least. Two layers of a white handkerchief will do the trick, or a recalculation based on a hypothetical aperture two stops larger than the one you are actually using.

4 Minimise the shadows. Choose a viewpoint where the shadows are largely hidden and become relatively insignificant. Then you can afford to let them remain underexposed and without detail.

5 Use only a part of the contrast range. The step is really an advancement of Step 4. Simply alter your viewpoint so that the subject can be contained within a manageable part of the overall contrast range. For example, instead of taking a portrait with side window light creating extreme light and shade on the face, turn the subject so the window forms the backdrop. Now the subject will be contained entirely within the lower portion of the range, and the highlights can be permitted to burn out.

6 Use a fast film. The inherently wide latitude gives a softer image, and will lower the contrast to something nearer manageable proportions.

Opposite, above: one of the simplest ways of handling the contrast problems caused by a strong, unrelieved sun is to eliminate it altogether. Move the subject into the kinder open shade.

Opposite, below: in the studio, you have absolute control. However, even there you can have problems. The right amount of contrast is required in order to give the subject the punch required in black-and-white pictures. Use the meter constantly to check on the ratio, and control lighting strength and direction accordingly.

Above: outdoors again, soft light reflected on to the face of the shaded subject has dealt with the contrast problem. *Manuel Torre.*

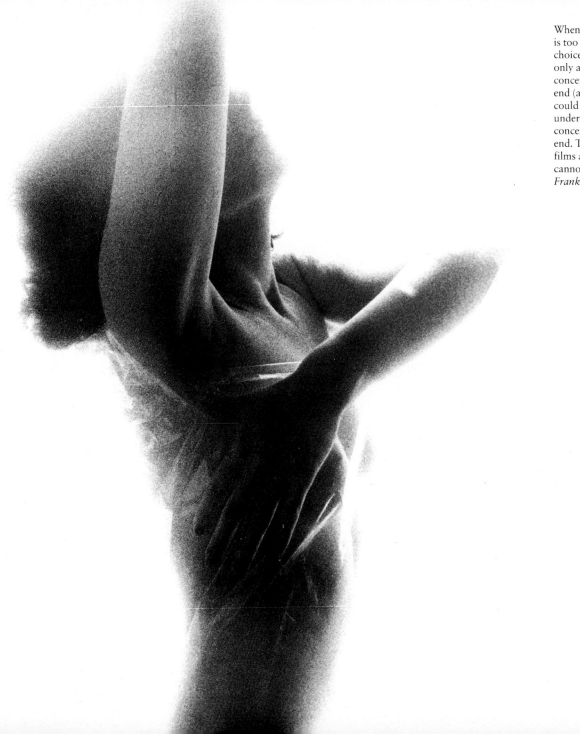

When the brightness range is too long, you have no choice but to make use of only a part of it. You can concentrate on the lower end (as in this case) or you could permit them to underexpose and concentrate on the upper end. The latitude of most films and printing paper cannot cope otherwise. *Frank Peeters.*

7 Use a wide aperture. With some lenses wide apertures produce softer images by introducing more lens flare. So where the contrast is great use the maximum aperture to reduce its effect.

8 Use a telephoto lens. Even though long lenses tend to be softer inherently, you have the additional softness resulting from increased distance. Telephotos drive you back and put extra space between you and the subject. Thus atmospherics such as dust, haze, etc. have a better chance to soften the contrast.

9 Use filters. A blue filter scatters light and reduces contrast. A polarising filter or a yellow contrast filter can darken the sky and bring its tone closer to the tones in the foreground. You can then afford to increase exposure somewhat, to put a little more detail in the shadows. However, filters need careful handling as they can also *increase* image contrast. Soft-focus or diffusion filters deliberately introduce flare, which softens the image by scattering light from highlights into the adjacent shadows. The result is an impression of a shimmering day, and contrast is lowered. Similar effects can be produced by smearing a thin film of grease on a clear filter; making a star-shape with transparent adhesive tape across your lens hood; shooting through a piece of net curtain; or simply using a starburst or other similar filter. An exploration of filters and effects appears on pages 61–69.

10 Overexpose and underdevelop. The first makes sure of shadow detail and puts plenty of density on the film. The second has the effect of reducing overall density and preventing too much build-up of negative contrast. The result is plenty of detail in both shadows and highlights and an overall reduction of image contrast.

11 Use high-dilution development. When your developer is diluted more than normal, the shadows tend to be built up while the highlights are held back, giving lower contrast in the negative. For a full explanation of negative development techniques refer to pages 85–100.

12 Darkroom treatment. The techniques you can use in the darkroom to reduce contrast in a negative are (a) use a softer paper grade, (b) use a soft-working developer, (c) use water baths during development, (d) use a diffuser in the enlarger, (e) flash the paper to light for about one-fiftieth of the exposure time. Printing methods are dealt with at greater length in the final part of the book (pages 127–160).

The 300 mm lens necessary to take this shot has brought the contrast within manageable limits.
Brian Gibbs.

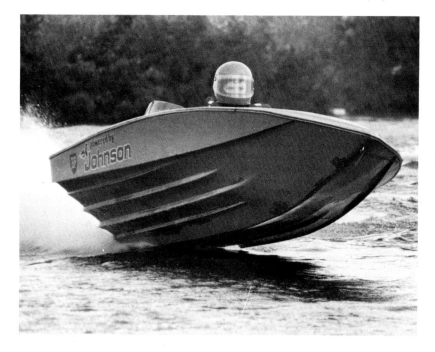

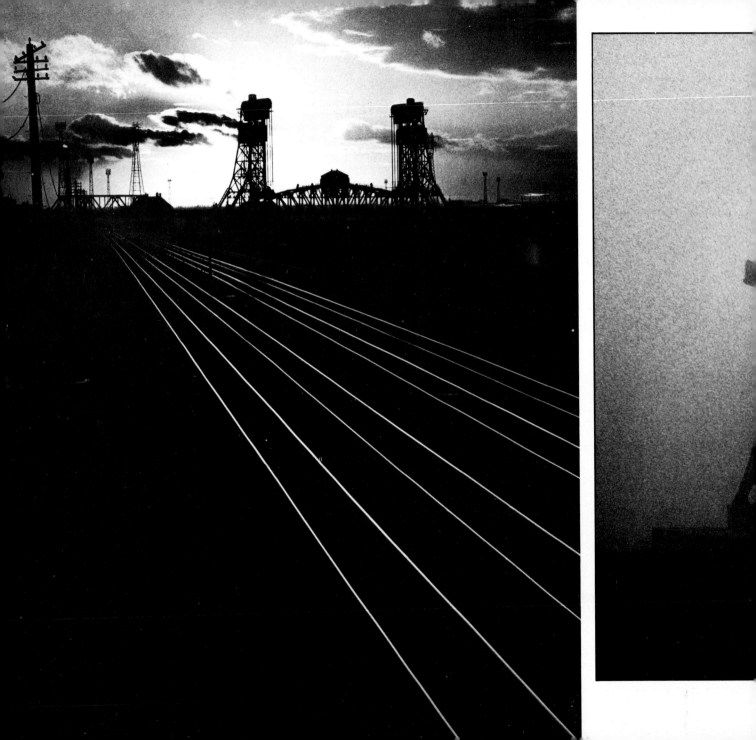

Exposure techniques

A picture is made in every sense before you press the shutter-release button. This has been said before, but is worth reiterating. The viewpoint must be selected, elements in the scene positioned in a satisfying arrangement, and the correct exposure assessed. Only then should you release the shutter. All these steps are interrelated; a good photograph is the product of them all. However, they can be divided into two separate categories: artistic and technical.

As in many aspects of photography, there is overlap. Training and experience often leads one to establish points of composition along well-tried, almost mechanical lines; witness the application of the rules of thirds and fifths, for example. Also, despite the mechanical process of exposure, there is much room for artistic licence. Nevertheless, the purely technical quality of the picture depends on the initial exposure. Development to the negative stage is linked, but no amount of darkroom sleight-of-hand compensates for badly-exposed negatives. Some limited redress may be possible, but the resultant negatives and subsequent prints will never have quite the sparkle and quality of one made by precise exposure. This, then, is the critical stage of the photographic process. If we have the power of theoretical knowledge, maintained by mechanical know-how, we are free to go in any direction the artist in us chooses.

Ranges and ratios

First, there must always be sufficient light to affect the emulsion. If areas are underexposed, nothing you can do in the developer will help. No method has yet been devised to put detail onto a film after exposure if none has been produced by the exposure itself. If it were possible, you could more or less throw the unexposed film into the developer and *will* a picture to emerge! The truth is that an

Michael Dobson (left), *Ben Storm* (above)

image is only formed by light reflected from subjects in front of the lens. Not all subjects reflect the same amount of light. Much depends on the amount and angle of the light falling on the subject, and on its colour, reflectance and surface qualities. In short, the brighter a subject appears to be, the more light it is reflecting; dark objects reflect less light than bright objects. Thus, between the two extremes of a black object in deepest shadow, and a highly reflecting surface in bright sunlight, there is a range of brightnesses all reflecting differing amounts of light.

The difference between the darkest part of the scene and the lightest is known as the *brightness range*. It is expressed as a ratio. On a sunny beach at midday, for instance, we may find that the highlights are as much as 1000 times as bright as the shadows. The ratio in this instance is easier to understand if you think of brightnesses as *units*. Unit 1 is the deepest shadow in which the presence of something can be sensed (i.e. not quite empty shadow), and the brightest highlight here is 1000 units. The ratio is thus 1000 : 1. Under thick, heavy cloud, however, the picture changes dramatically. Those same areas measured may now show the brightness of the highlights as only 32 times the brightness of the shadows. The units then are 32 and 1 respectively, or a ratio of 32 : 1.

After correct development, the first unit on the negative should show just a trace of density in the shadows, the barest hint of tone. At 2 units it is stronger, with textures just visible; at 4 units full shadow detail can readily be seen and the tone is a definite grey. Over units 8, 16, and 32, the detail is clear as the negative density increases progressively. then at 64 and 128 units most of the available silver halides will have been developed. Total black is reached beyond this point, because almost every particle of silver halide has been reduced to metallic silver, and textures and details are totally obliterated. During printing, the light is held back by the denser portions of the negative, which reproduce as highlights. It is passed more freely by

the clearer areas to produce dark tones and shadows.

Latitude

Two factors arise out of this. First, the units we chose moved from lower to higher brightness by doubling, thus linking to the aperture and shutter speed series. Each successive *f*-number passes twice as much light as its smaller neighbour, and each successive exposure time twice as much as the next. The second factor relates to the ability of the film to handle a brightness range. Above a certain point it does not matter how much extra light energy you pour onto a film, as all the silver halides have already been affected. If the saturation point occurs at (say) 256 units, then a negative area receiving 1000 units is no more dense. When printed, it is not possible to tell the difference. Likewise, at the other end, below 1 unit, it does not matter how dark the subject is; the density can go no lower. Thus, zero and ten steps below zero will both produce clear film (give or take a small amount of base fog). They

In this case, exposure was adjusted to suit the mid-tones of the face and hands. The highlight areas produced by the backlighting have been allowed to 'burn-out', enhancing the effect. *Ed Buziak.*

Beach scenes and seascapes such as this can contain a brightness ratio of something like 1000:1, in which case compromise in exposure is the order of the day. *Ed Buziak*.

will all appear as solid black on the print. This is clearly seen in the grey scale, which shows the various density steps and the extreme areas of no detail.

The latitude of a film determines how much of the total brightness range it can cope with. For all practical purposes, a monochrome film is blank below 1 unit and reaches maximum density at 256 units. That is to say, it can show tones and detail within a brightness ratio of 128 : 1, or seven stops. In practice these ratios vary from emulsion to emulsion. The speed of the film decides the actual latitude. Slow films fall a little short of 128 : 1, whilst faster ones extend beyond it. Then there are various after-treatments you can apply, as suggested in the previous chapter, to modify the brightness range present in the negative.

The contrast grade of the paper on which the negative image will ultimately be printed is important. Ideally we should aim at producing a negative to print on Grade 2 (normal) paper each time. However, Grade 2 paper can handle at the very most only a seven-stop spread of brightnesses. Therefore, regardless of what our film might be capable of, we must proceed on the assumption that its latitude is limited to 128 : 1. Now, our original beach scene has a brightness range of 1000 : 1 (ten stops). The paper, and possibly the film, cannot handle it all and still show detail at each end. You are now faced with a decision as to which seven consecutive stops of the ten you are going to fit onto your film.

One way is to put your film's first unit on the brightness unit of 4 in the scene. This would make the highest latitude point of the film coincide with the brightest part of the image, and ensure detailed highlights. The problem is that most shadow areas would then be a uniform solid black. Alternatively, you could try positioning unit 1 of the film on the scene's first unit of brightness. Thus you would get plenty of detail in the shadows, but as your film reaches maximum density at the saturation point of

256 units (the eighth stop), the higher brightnesses in the scene (units 512 and 1000+) would record in the print as blank white. You would be, in effect, sacrificing the highlights for detail in the shadows. You could also compromise and select a range in the middle. This time you would lose something in both shadow and highlight extremes. The choice is yours; this indicates the point at which the mechanics of exposure end and personal creativity begins.

On cloudy days you have the reverse situation; the brightness range may extend only over a 32 : 1 ratio, leaving you with two extra stops of latitude. Thus you can fit the scene within that latitude wherever you like. You have the choice of a number of exposures, each of which will still contain the brightness range of the scene.

Meters and tones
Most meters, including all those built into cameras, measure the light reflected from the subject. Although they are able to give you precise information about the brightness value of any part of the scene, they are designed to read in averages. They see every scene as mid-grey. For an average reading of a general scene, this is fine. The meter takes all the lights and darks, and the in-betweens, and as long as these are evenly balanced it will suggest the correct exposure. The indicated exposure embraces all the tonal values. If they extend beyond the established seven stops, the meter will choose an exposure somewhere in the middle of the film's latitude. However, if there is a large dominant tone in the scene the meter can give a misleading indication. Should the tone be mid-grey, all is well. Measure a white one, however, and your meter gives you a higher reading. Shoot at the settings suggested and that white will appear on the negative and finished print as mid-grey. As a result, the darker tones in the picture will be underexposed. For a black area, the meter does the opposite. You get a measurement that is too low, so that all the light areas in the scene are overexposed.

Taking the meter reading from a brightly lit mid-tone renders it a mid-grey standing out starkly against the shadow areas (and against the sky in this shot, because a red filter was used: see later). *Ben Storm.*

As an example, consider a dark building standing next to a light one. The light one gives you an exposure measurement of $f/16$ at $\frac{1}{250}$ second. The dark one reflects only sufficient light into the meter cell to produce $f/2.8$ at $\frac{1}{250}$ second. Both are accurate as far as subject reflectance is concerned, but neither gives the correct reading. If this method were followed through to its logical conclusion and you metered the variety of tones individually within a general scene, you would get a confusingly different measurement each time. At a shutter speed of $\frac{1}{125}$ second, for instance, you might get $f/2$ from a doorway leading to an unlit room, $f/4$ from an open shadow, $f/11$ from a brightly lit wall, etc.

In both examples, a constant is required; this can only be a mid-grey tone, an average. In our example, $f/5.6$ falls in between the two extremes and makes a reasonable average so that both the buildings and the surrounding scene receive the

Right: the meter will automatically give you a mid-grey, or Zone V, no matter what the tone of the original subject. This means that you must apply manually the adjustments needed to bring the tone back to where it should be. In this case the natural colour of the stone lion was Zone III. In order to attain this the aperture was closed down two stops after metering.

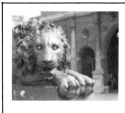

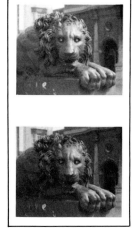

Below: a white door or other light object can easily fool the meter. A direct reading causes the meter to average the tone and give you a setting that makes it mid-grey on the negative. Lower values which appear in the scene are pushed down the scale into underexposure. The only way to compensate is to add density after metering: open up by the required number of stops to force the white door up to its proper position on the scale.

Left: each tone in a scene tells your meter something different, but the meter averages all the tones to a mid-grey. Therefore a light scene is underexposed and a dark one is overexposed, having been given readings too high and too low respectively. In these pictures, when the darker building (left-hand picture) was metered, the reading was ¹/₂₅₀ second at *f*/4; a measurement of the light building (right-hand picture) gave ¹/₂₅₀ second at *f*/11. In the first case, lighter parts of the image were overexposed; in the second, darker parts were underexposed.

Right: if you adjust the aperture to control one tone, the rest are affected too. Efforts to produce a strong sky as well as detail in the jets have led to a compromise. The jets, as the darkest part of the subject, were metered first and set on Zone V to ensure detail. Then they were progressively moved down through Zones IV, III and II, while the sky was monitored. Only when the jets read Zone II was the sky the correct value, but that left them without detail. They were then raised to Zone III and the sky, while lighter (Zone VII instead of VI), is acceptable.

correct exposure. It becomes clear, then, that everything in a general scene, regardless of its actual, individual brightness value, should have the same exposure. Only by finding the average to satisfy the meter can you assign the variety of tones into their proper places in the tone scale.

Where there is only a very light tone to meter, we must add density after measurement by opening the aperture to prevent it recording as a mid-grey. One stop makes the value a tone lighter on the print; two stops, two tones lighter, and so on. For a dark tone, we close down the required number of stops. These additional steps are the only way we can return the subject to its proper tonal value and expose the negative correctly.

Since through-the-lens meters measure reflected light, this ability to interpret and re-evaluate what the meter is telling you is important. If you use a spot meter it is absolutely vital. The spot meter sees only a tiny portion of the image. Its angle of acceptance can be as narrow as 1°. Compare this with the 30° or more seen by an integrating meter, including those which read through the lens, and you can appreciate the value of careful measurement and interpretation. Mostly the spot meter sees only a single tone. You have to know what to do with it after you have measured this.

One way of overcoming this problem is to avoid measuring the scene at all. Take a reading instead from a specially designed 18 per cent reflectance grey card. Such a card is used by the makers of meters for calibration purposes, and can be obtained from photographic suppliers. As long as it is held in the same light as the scene, the meter will give a correct exposure reading, and it will not be influenced at all by different tones within the scene. As a bonus, all those values in the scene are automatically placed in their proper tonal positions. It works whether you are faced with a multitude of tones or a single one. If you do not have your card with you, try metering the palm of your hand. The value is about the same as a middle

grey, perhaps a shade lighter or darker, depending on skin colour.

Incident-light metering At first glance, the incident-light meter seems to avoid all this. Using an opal diffuser over the light cell, it measures light incident on (i.e. falling on) the subject (rather than light reflected from the subject); the reading is thus unaffected by the dominant tones in the subject. What is more, if the brightness range is longer or shorter than the film's latitude, it will always place the exposure squarely in the middle. The snag is that, as you have not metered important tones within the picture, it is not easy to know what the relationship of the latitude of your film will be to the scene's brightness range. Nevertheless, despite this shortcoming, the incident-light meter is extremely accurate for general reading when used correctly.

More difficult subjects
Whichever type of meter you have, there are photographic situations which may catch you out, or which require some interpretation. To help you deal with such problems, here are six of the most common:

1 Dominant contrasting background Large, dominant tones within the scene will affect the meter enough to give a false reading. You get too high a reading for a light background, and too low for a dark one. The results are respectively under- and overexposure. Naturally, it is the *subject* which must be exposed correctly; the background does not matter here, so it should not influence the reading in any way. Consider a portrait, to be taken with a dark background. A general reading from the camera position with an integrating meter may give, say, a reading of 1/60 s at f/2.8. However, a close-up reading of the face alone (making sure the background does not influence the cell at all) suggests 1/60 s at f/8. Reading from a grey card we find that the correct setting is 1/60 s at f/5.6. Now change the background for a white one. Camera position reading this time will probably be 1/60 s at

A dominating dark tone can lead to an underexposed image. The meter turns it into a mid-grey and pushes other tones well down the scale. Make sure you measure only the important part of the subject.

When aiming for detail in a backlit subject, and the highlights are not important, you can make the shadow side lighter than would otherwise be possible. The eye accepts such tonal values at one or two stops higher.

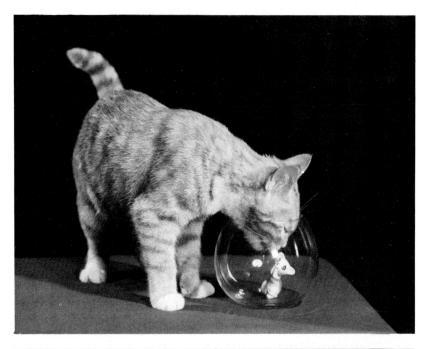

f/16. The close-up reading will stay as before, as the lighting has not been altered, and the same amount of illumination is falling on the face. For the same reason the grey card reading will not alter. Only the background is different; but this does not affect the subject. If the camera position readings had been used, the face would have been two stops over- and underexposed respectively. Although it may be felt instinctively that the face with the white background is lighter, this is not so; it remains the same. For this problem the best type of meter is the incident-light type.

2 Backlighting In some ways this problem is similar to the one above. With the main light source behind the subject, the effect is an extremely bright background, contrasting strongly with the foreground subject. In this case, the principle of exposure measurement remains the same, i.e. ignore the background and establish the exposure that the subject itself requires. However, at this point it does differ. There are two approaches you can make to backlit shots: either turn the subject into a silhouette, or expose for complete detail. One way of achieving a silhouette is simply to point the meter cell at the light source. That will push the remainder of the tones far enough down the scale to ensure little or no detail can be seen. Another method is to use the technique outlined in the previous chapter. Meter the subject directly and then close down the aperture the required number of stops for the tonal value required. About four stops will give you a silhouette. On the other hand, if you want full detail in the subject, take a close-up reading as before, and then open up two stops. Again, you have total control and can place the values where you want them to be. Above two stops more than the reading, you move into the realm of high key. It is worth noting that where the subject is in total shadow, and the highlights do not matter, you can raise the tonal value of the subject higher than 'natural' without destroying its acceptability. For this problem the best type of meter is the spot meter.

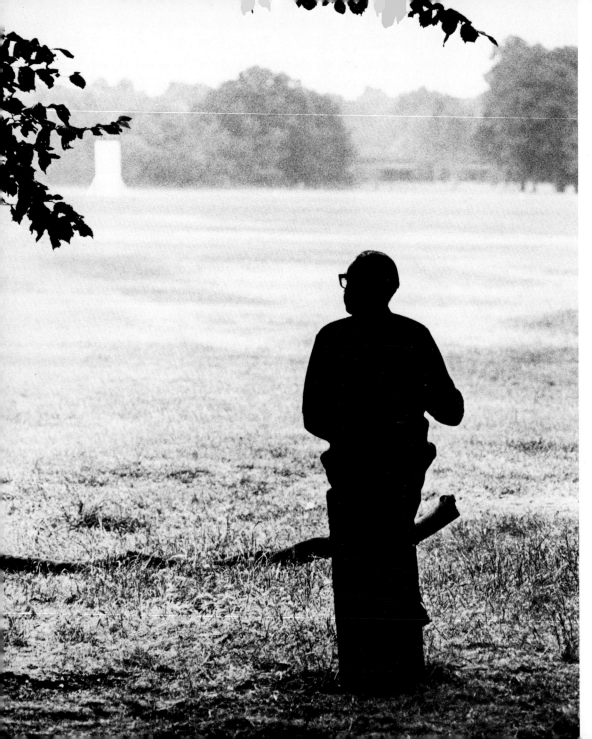

To obtain a complete or partial silhouette, simply point the meter cell at the light source. Greater control is possible if you meter the subject directly, then close the aperture down by several stops in order to achieve the effect you previsualised.
Raymond Lea.

3 Extreme cross-lighting Even though this lighting is useful for emphasising three-dimensional form and texture, as we have already discovered, it does present exposure difficulties, particularly for reflected-light meters. It tends to give inflated readings causing the shadow areas to be underexposed and lose detail. You can, of course, learn through experience to make a manual adjustment after reading. An alternative, and perhaps more reliable, method is to make a two-tone reading. Meter first the highlight side, and then the shadow. Provided the contrast ratio is not too high, the average should be just about right. A simpler method is to use an incident-light meter. No correction will be necessary unless the shadows are very deep, in which case exposure may be increased by one to two stops. Of the three types of meter the incident-light type is best for this problem.

4 Water More potentially good seascapes and pictures including water have been ruined by its high reflectance than by anything else. Water tends to bounce back the brightness of the sky, almost to the same level. It will catch your meter out if you do not give some thought about how to cope with it. Knowing in advance that water inflates reflected-light readings is half the battle. A spot meter scores here; it is able to pick out the subject of interest, even if it is a tiny object surrounded by a great expanse of water. An incident-light meter will not even recognise its existence. If you have only a TTL meter, or a hand-held, averaging type, you would be better advised to use substitute subjects (grey card or hand). Make sure, however, that they are in the same light as the subject. For this type of problem the best type of meter is clearly a spot meter.

5 Night scenes Night-time neon signs, illuminated shop windows, street lamps, and so on, look pretty and urge the attention of your camera. An integrated-light reading from the camera position will get you a great picture of the lights themselves.

Water is notorious for giving inflated meter readings. Subjects that are in it or surrounded by it are pushed down to underexposure. Play safe by taking a substitute reading of a grey card held in the same light, or measure the incident light.

At night, unless the dominant shadows are catered for, the brighter lights cause them to render without detail. Meter the lights and then open up the aperture by three or four stops, or meter the shadows and control the detail as you would with a backlit subject.

The snag is that they will be in an inky black sea. Nothing of the streets or other background details will show. The meter, as usual, is influenced by the brightest part of the image, i.e. the light sources, and gives you exposure estimates which are much too low. You do not want the lights to be averaged into the middle of the scale. You need them right at the top, where they should be, at the extreme upper range of the emulsion. Then the important lower tones, which make up most of the image, will be within the bottom limits. You could, of course, try reading from some of the lower values themselves and closing down the aperture a further two or three stops to position them at more or less their proper values. But, since they tend to be very low, it is possible your meter will not even register. Often there is only one course: guesswork. The more night photography you do, the more adept you will become at recognising various night 'brightnesses'. Thus you will be able to select actual exposure settings which, together with exposure 'bracketing', permit you to expose fairly accurately every time.

The best meter for night photography is a spot meter. In this situation an incident-light meter is virtually useless.

6 Extreme close-ups Very tiny subjects may defy reflected-light metering because it is impossible to use the meter without casting a shadow on the subject. If you move back, the background will exert undue influence on the reading. A grey card is one answer, but a better method is to measure the incident light. When taking extreme close-ups with a macro lens or with lens extension tubes or bellows, you will still need to make a further correction. This is because the lens is much farther from the film than usual, and the *effective f*-number (which is the lens extension, *not* the focal length, divided by the aperture diameter) is different from the marked *f*-number. There are two ways to make a correction. The first is to find the effective *f*-number. This is given by the expression:

$$\frac{\text{marked } f\text{-number} \times \text{lens extension}}{\text{focal length of lens}}$$

accurately. It cannot adjust to abnormal subjects, or to your individual whims, by itself. In nearly all problems of exposure, it turns out that the answer will be found in the identification of an important tone, from which, with the help of the meter reading, an evaluation of the exposure can be made. Provided the brightness ratio is acceptable to the film, the adjusted tone value will position all the other tones correctly. Recognising that the control of tones is vital for making precision exposures – the key to good black-and-white pictures – the next step is to become thoroughly practised in exploiting your meter to this end.

Precision metering

In 'Black-and-white vision', the problem of the translation of colour to tones was touched on. Following pages have made it clear that in order to be successful with monochrome photography you must be acutely aware of the tonal values represented in the scene. They should be assessed and arranged to provide maximum effect.

By now you will have discovered the difficulties of seeing a colourful scene in monochromatic values. The viewing filter does help, of course, but it can only furnish you with limited vision and, by and large, show you when there is sufficient tone separation, or too much. The answer is found in the reflected-light meter methods we have been looking at. For instance, if you have already discovered a mid-grey tone and have made your average exposure, you have a basis for discovering something about the rest of the scene and taken a big step forward in being able to see in monochrome.

Let us say your average gave you $f/8$. Now you meter some nearby foliage and find that, at the same shutter speed, let's say $1/125$ s, the aperture reading now drops to $f/5.6$. That means one stop less light is being reflected, and it will therefore reproduce on the film as one step darker. A reading on a doorway may be $f/2$, or four stops less. This gives you a clear image of what is going to happen

Small subjects can cause problems unless metered with care. Surrounding tones influence the readings, but since the subject is so small it is difficult to take a reading direct. An incident-light reading will do the trick, or a measurement from a grey card. *Neville Newman.*

To find the lens extension you simply add the lens focal length to the amount you have moved it forward from its 'infinity' position. The other method gives the increase in exposure directly. The proportional increase in exposure is given by the expression: (magnification of image + 1)2

For example, if the image scale is 0.7 times that of the object, the proportional increase in exposure is 1.7^2, or approximately three times the metered exposure. If the image is twice the size of the object, the required increase is $(2 + 1)^2 = 9$ times the metered exposure. That may seem a lot, but it is what you would have to give. By the way, if you use TTL metering you do not have to make any compensation, because the meter automatically takes it into account.

Thus we see that correct exposure is the product of meter allied to mind. Do not think that the meter can do all the work. The meter can do only what it has been calibrated to do, i.e. measure light

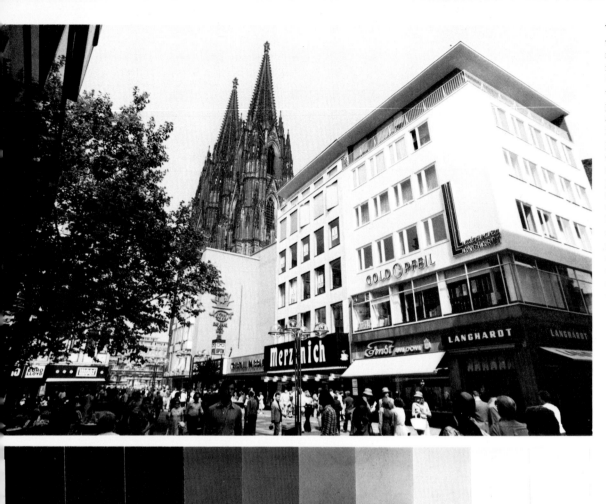

The famous Cologne Dom was 'anchored' on mid-grey, a straight meter reading, giving settings of $^1/_{125}$ second at $f/8$. The light wall on the white building proved to be four stops above the metered value, indicating that it would be paper-base white. The darker portion of it was one stop lower. The darkest part of the trees were five and six stops below the metering point. This would be so underexposed as to record no detail. Lighter parts of the same trees were only two stops below. The other tones appeared to fall satisfactorily, so the picture was taken.

to that part of the scene, for you know that four stops less than average (or mid-grey) gives you only a hint of tone on the film and will be virtually black on the print. At the other end, some light stonework may read $f/11$, and a yellow sign read $f/22$, i.e. one and three stops respectively above the average reading. In the first tone you will see light grey; in the second you will see little detail because the sign will be almost burnt out.

Visual values

Now you can see how a detailed accounting of tones in the scene will help you to visualise what the finished result will look like. The colours of the objects are more or less incidental. The important issue, and the key to visual translation, is the reflective brightnesses. Meter these, and place them visually, and you gain a clear impression of the final image in monochrome.

This is, in fact, the basis for the Zone System. Originated by Ansel Adams and embraced and promulgated by such notables as Fred Picker and Minor White, it is a highly sophisticated form of negative production. There is a great deal of mystique about the Zone System for those enthusiasts around the edge. When you break in, you find that it is simply a precision method for obtaining preconceived results, from image sighting to Fine Print. Moreover, it helps you decide how you are going to achieve the preconceived image through the various stages before you even make the exposure. Perhaps its greatest value for the black-and-white enthusiast is that it links the various tone readings to a visual key or 'grey scale'. When you can directly relate an exposure check of the type described above to definite shades of grey, then you have a concrete vision of how those tones will appear in the print. Of course, the range of tones is continuous, from white at one end through to black at the other. But that is hardly of help to you; so the stepped grey scale has been devised to simplify the job. Arbitrary steps indicate the full range of the scale in stop values, each one doubling or halving the brightness of its neighbour.

Zoning

The Zone System, not unexpectedly, calls these steps 'zones'. Each zone is given a number; with experience the user begins to cotton on to which subjects fall on which zones. The zone numbers are given in Roman numerals, plus a zero value. Zone 0 is total empty black, and Zone IX is sold, burnt-out white. Middle grey is Zone V. So in our example above we will have found an average tone, say some grey stone, to give us Zone V. The foliage reading is one stop less and falls on Zone IV. The doorway, which was four stops less, is on Zone I. At the other end, the light stone falls on Zone VI (one stop more), and the yellow sign, three stops more, on Zone VIII. By making a direct comparison with the relevant zones on the grey scale, you can actually have a vision of the finished black-and-white print almost forming before your eyes.

After you have played around with the system for a while, it becomes clear that it enables you to be absolutely precise in placing tonal values. For example, suppose you are shooting the backlit scene against the light mentioned on page 47. If you take an average reading, you know that the brighter values will give you an inflated reading and reduce exposure for all the other objects. They will become silhouettes. Do you know just how much detail will record in those silhouettes? Even if that is what you want, can you be sure it will match precisely your conception of the completed image? The answer must be 'no'. All you know is what the average light is, and you may be reduced to bracketing exposures to make sure.

Now try it the Zone System way. Meter the shadow area direct. Let us say it is $f/4$. You know that if you leave it there and shoot, it will record as middle grey on the negative, pushing the higher values right over the top into gross overexposure. Close the aperture down a stop to place it on Zone IV, and you slide the other tones down a stop darker. Make it two stops, to Zone III, and you are into the low values, but still showing plenty of detail. Now move down to Zone II. This is three stops less than measured; at an aperture of $f/11$, you have a silhouette with just a suggestion of detail and texture. This would be a good position to shoot it. Now check the highlight values, and see where they fall. If they are on Zone VIII or IX, that will be fine. You will have the barest traces of tone there too. Any higher, and you are into specular reflections which will register as pure white on the print. By using this method, you have taken the tone accounting a stage further. Instead of finding out just where the other tone values lay, you are now employing the system to exercise full control over what you see and how it will appear on film.

Finding an anchor

Accounting for tones raises an interesting problem. When you start working their positions out, you must first of all establish a basic exposure. Now, in the case of working out a silhouette, the subsequent

You can exercise control over what you see, and how it will appear on the final print, by adjusting the aperture. Conjure up an impression of what you want in your mind's eye and use your meter to produce it. A dark value was required here. In the first step, the meter gave, as usual, Zone V. This placed the sky in Zone IX–X. Close down the aperture for step two, making the cross and stand Zone IV, and the sky is lowered too. A further stop moves them to Zones III and VII respectively, and another two stops brings them down to Zones I and V: this time too far. Step three fits the preconceived notion of how the image should look.

closing down of the aperture sets it for you. But, in a straightforward lighting situation, oddly enough, it is not a simple matter. You need to establish an average setting, which means locating a suitable value to meter. This does *not* necessarily mean a mid-grey. You can meter any value, and as long as you know where it should be on the grey scale, you can open or close the aperture to establish the basic setting. And that is the problem in the beginning: identifying tones.

There are a number of everyday objects which customarily fall in the middle values, Zones IV to VI. If you can identify these, you have a variety of sources for establishing your 'anchor' exposure. Some are listed in the table.

Zone IV	Zone V (mid-grey)	Zone VI
close one stop	straight reading, grey card	open one stop
Skin in shadow	Dark skin	Caucasian skin
Landscape open shadow	Sunburn	Snow in shade
Building open shadow	Weathered wood	White concrete under
Dark stone	Grey stone	overcast sky
Dark foliage	Light foliage	Light stone

The idea is to start with a known value. Look for an easily identifiable one, or a tone over which you want control and know where you want it to be. Let us say it is a human face. The chart suggests Zone VI, and reference to the grey scale satisfies you that it is correct. Zone V is too dark. Therefore, after measurement, you open the aperture by one stop. Now you have your anchor exposure. Other tones can be accounted for, and discovered at what points on the scale they will fall. That gives you the visual image of the scene in terms of shades of grey required for pre-visualisation. Where you cannot find a suitable tone, you can always use your grey card, or the palm of your hand. In every case, you will realise the importance of taking the meter close to the tone to be measured, or of using a spot meter. No other value must be allowed to influence it at all. If your anchor zone is shifted, everything else will shift with it. While this may not create any special problems in the middle values, at the shadow and highlight ends it could be critical.

The processing link
The point has been laboured that successive steps in the negative-positive process cannot be taken separately. You must not divorce print-making from film development, nor film development from exposure. Indeed, this entire chapter has been devoted to a method of visualising the finished product before you have actually released the shutter, and relating it to exposure. In the middle, development to the negative stage is linked, too. The idea is to develop the film in such a way as to reproduce the negative which precisely represents your exposure manipulations. You have taken the trouble to expose for the right shade of grey; it is important that your development procedure drives you towards that visualised goal.

During development, the highlights begin to form almost immediately. These are the areas of the negative which have received the greatest amount of light and are, therefore, the densest. Since they are full of exposed silver halide, they are quickly reduced by the developer to metallic silver. A little later the less affected areas begin to appear, and so on down the scale until the image in the shadow areas, which has very little exposed halide, starts to form.

Now, the trick is to permit the film to remain in the developer for the exact amount of time to allow each value to reach the correct density. With the regions of lowest exposure, i.e. the shadows, this is not so critical because once all their few exposed halides are developed they become little denser. However, at the highlight end, things are different. Highlights have more halide exposed than is required for a detailed image. If you leave the film in the developer too long, the image continues to gain in density, destroying detail in the process. Conversely, if you do not leave the film in long enough, there is insufficient density overall and the

pictures loses impact and sparkle, not to mention having under-valued greys. The important thing is that development must be carried out in such a way as to ensure correctly valued greys, as well as a correct relationship of these greys to one another. What you do during exposure determines how you must treat the film in the developer (see page 85).

While expressions of mood are best undertaken during the exposure of the negative, as we have seen already, one can to a limited extent print down or up to enhance emotional expression in the final picture. It is necessary to examine the scene or the image closely to see if there is any way in which it can be improved. Not every possibility for mood enhancement may have occurred to you when you were at the scene; the pressures at that time may have been too much. However, when you have the test print before you, you can examine every aspect of the image at your leisure. Your mind is freer and creativity is able to come to the fore.

Low key
Tones in themselves can be emotional. Dark values, for instance, are sombre; when dark shadows dominate a scene, the subjective experience is of mystery, sadness, even death. There is a power in dark tones which stirs and touches deep down inside. The precise effect, however, depends on the environment it expresses. Let us raise old Dracula again, for a brief moment. There he sits in his castle, embraced in deep shadow. There is fear, the deep foreboding that something evil is about to happen. Compare this with a scene of an old woman in dark, dingy surroundings. This scene, too, is full of dark tones, but here we feel something different: sorrow, horror, perhaps compassion. Try to look at important masses in the scene, and decide at what value they should be to express your emotions. Instead of recording them at their natural value, think again. A Zone V, as an example, may be stronger if lowered to Zone III or even Zone II. Now check to see how this will affect the other tones and masses. Perhaps Zone III is as low as you

dare go, and you will have to lower this area individually at the print stage by burning-in.

The term for darkened values such as this is 'low key'. In a low-key scene the lower values dominate and allow the higher values to be emphasised only through isolation. There should be plenty of dark tones in the scene to start with. All you do is lower them further. To produce them from nothing is fraught with problems. However, when the values

A darkening of tones often improves the overall appearance of the image. This has been achieved here by printing down; while both pictures would be acceptable, the darker one adds an impression of foreboding.

do not seem to be quite right, you can help things by swinging your viewpoint around so that you are shooting into the sun. Then objects between can be rendered as low as Zone 0 if need be.

High key

Light tones, on the other hand, have a happy feel about them. They can be used to express summer or bright sunlight, and can evoke memories of laughter, enjoyment, youth, and the like. They can

be emphasised in a picture by reversing the exposure procedure outlined above. Place Zone VI on Zone VIII or IX and lighten the whole image (the need for a check on the other zones goes without saying). You are now in the realms of 'high key'.

The difference between shifting the key during exposure and shifting it during printing becomes very clear at this stage. In a scene, you will probably find that the deeper shadows range lower than the point where you have placed Zone 0. If you expose the film at that point, because it can show no values lower than Zone 0 the original low zone numbers will all show up as the same black. If you raise the key in printing those low zone numbers will be raised too, along with everything else. They cannot stay black, even though they were originally lower than Zone 0. If you do this at exposure, however, the story is different. If these lower values were, say, Zone 0 minus 4 stops, and you push the key upwards by adding three stops exposure, you still have Zone 0 minus 1 stop. In other words, you still have deep rich blacks.

To suggest that a black is out of place in a high-key picture is wrong. Granted, there should not be large areas of black or the scene will not be truly high-key. However, even a tiny portion of black acts as a focal point and provides a sense of depth for visual effect. It may be as small as the pupils of the eyes in a portrait, or a distant, shadowed cottage doorway in a beach scene.

Of course, key shifting, or rather the mood evoked by it, is a personal thing. It is no good expecting that you will please everyone all of the time. All you can do is please yourself, and hope that there are sufficient who think as you do to make the picture a success. It is all made possible by paying particular attention to the tones present in the subject, and not merely accepting them but making them *work* for you, to emphasise the parts of the image you consider important.

Tone relationships

The variety of tones within a picture can be
expressive in either a vivid or a subtle way. For
instance, in the low-key picture, if the values are
lowered far enough, you could be left with just two:
shadows and highlights. The visual power
possessed by such two-tone pictures, with their
sharply contrasting values, is striking indeed. The
reason for this is twofold. First, the contrasting
tones act upon and emphasise one another. The

whites seem to be whiter, and the blacks blacker.
Second, where the tones overlap, the contrasting
values delineate each other's shape clearly.

But now we come to an interesting visual effect. If
the lighter tones are grey rather than white,
although the separation is still there the image will
have lost some of its impact. As the grey becomes
darker, so the contrast and impact lessen.
Moreover, as one value is altered so the other, too,

Predominantly light values (high key) are achieved during exposure. There must be few shadows present; but if the exposure is correct, denser portions of the subject retain their values on the print. If you try to achieve high key by simply printing lighter, the darks are raised too, resulting in the loss of any black and a lack of impact. *Ben Storm.*

is apparently affected. Although there is no actual tone change, the progressive darkening of a lighter background seems to lighten the foreground tone, dragging it along. By the same token, if you lighten the background the apparent tone-separation is further increased. The foreground appears to become darker, seeming to raise the contrast.

Another visual point arises from extreme tonal relationships. Lighter values, of course, reflect more light than dark ones; this makes light areas appear larger than dark areas, even when in fact they are the same size. This illusion, however, is counterbalanced to some extent by the apparent 'thrusting forward' of the dark values. Both of these effects are useful devices for creating illusions of depth, and strengthening certain parts of the image.

These visual features are important in compositional arrangements, regardless of how

As darks seem to project forward, they are a useful device for introducing the impression of depth to a picture. They contrast sharply with lighter background tones. *Paul Broadbent.*

The idea of visual impact through contrast is even more marked when the scene includes a human being. Even though they may form a tiny portion of the total picture area, people excite interest and catch the eye.

small they might be in the picture. As long as there are no other dramatic contrasts in the scene, even small darks against lights will catch and command the eye. You can use contrast in this way to separate the subject from a messy background. Choose a viewpoint which places the subject against a part of the background with which contrasts tone, and it will be clearly discerned. If the subject is a human figure, it will command even greater attention, no matter how small it is. This is a psychological effect; the viewers will seek out a human figure every time. And when it has attention drawn to it by its contrast against the background, it dominates the image. However, not every picture has to have the impact of vivid contrast to be a success. Indeed, the tones can be quite close together and still give a soothing impression of harmony. In mist and fog particularly, tonal values are subdued and the greys move to the middle of the scale. There are virtually no blacks or white. The tones appear to flow into one another, giving a strong feeling of quiet and peace. Any blacks and

white are present only to provide a centre of interest.

This small centre of interest is desirable because it prevents the picture from losing its visual effect. Even in a tranquil scene such a visual point is useful. Because of its immediate attraction it should be an important part of the picture. As a secondary subject, it is too strong and will draw the eye away from the main subject, unless that too is strong. The only way to achieve such a saturated tone in mist or fog is to be close to the subject. It is the fog itself which causes tones to be subdued into greys. Thus, the less fog there is between you and the subject, the less subdued will be the tones of the subject.

Local tone adjustments
So far we have been looking at ways of dealing with tonal values which are already there. These are generally shifted in their entirety by manipulations of exposure and development. Local changes are possible only during printing, where, to a limited

You do not need sharply contrasting tones in every image to achieve interest. Tones predominantly of the middle values, and quite close together, can also produce subjective impressions in images. Here, the feeling is of quiet solitude.

degree, dodging and burning-in provide a means of lightening or darkening certain values. There will be times, however, when we want to make greater adjustments, in a way that the fundamental skills of exposure, development and printing do not allow. In this event we turn to the use of filters. With filters you can change and dramatise values to influence the general mood of the picture. For instance, if in a low-key picture you wish to raise the value of, say, a red door, then you would shoot through a red filter. Not only would it achieve the effect you were after; it would also deepen the contrasts, for a stronger low key.

But perhaps that is going too far ahead. Let us step back a bit, and have a look at how filters work with black-and-white film. Panchromatic emulsions are sensitive to the whole range of hues in the visible spectrum, unlike the earliest emulsions, which were totally blind to red. This sensitivity is, for the most part, fairly uniform across the visible spectrum. However, the response of the eye is not uniform;

for example, it is much more sensitive to yellow than to red or blue. So the film does not respond to colours in the same way as the eye. Therefore, many of the greys we do see in the final picture do not correspond with the brightness we expect. For example, foliage reproduces too dark to be acceptable; tomatoes and other red fruits, too pale; and the sky has a habit of burning itself out. A filter of the right hue corrects this, raising or lowering the various colours on the grey scale so that each becomes more acceptable. This it does by altering the content of the light reaching the film. As we saw in the red filter and red door example above, a filter will pass its own colour unhindered, while altering others. A red filter passes red light and other colours containing red to increase the density of these negative areas. They then print lighter. However, blues and greens, and other colours containing them, are absorbed by the red filter, and record darker in the final print.

Correction and contrast filters

Filters for black-and-white photography can be separated into two groups: correction filters and contrast filters. The first corrects the emulsion's response to the colours seen, and the second exaggerates their differences for special emphasis. The division between the two types is sometimes only in the depth of the filter's colour. A light yellow, for example, corrects, whereas a deep yellow falls into the contrast category. Others, however, such as red, are contrast filters regardless of depth. Filters in each of the categories are:

correction filters	contrast filters
light yellow	deep yellow
medium yellow	dark green
yellow green	orange
light green	red
light blue	deep red

Because the filter stops some of the light from reaching the film, overall exposure is affected. Tests for determining filter factors are described on page 139. It is vital that you know these precisely, for the meticulous tonal adjustments you are now capable of. Since you are working to such precise limits you cannot afford accidental underexposure. Even a slight mistake can push the delicate value placements down far enough to destroy the first impressions of texture of Zone II and of detail in Zone III. If you follow the suggestions closely, you will make your tests under various lighting conditions. This is important because the type of light source can affect the filter factor. The reason for this is the spectral content of the light. 'Warm' (i.e. reddish) lighting, for instance, will influence 'warm' filters such as yellow, orange and red only slightly, so that these require less adjustment in exposure than the 'cold' filters, the blues and greens. Tungsten filament lamps, and daylight at sunrise and sunset, are examples of 'warm' sources, whereas noon sunlight, overcast daylight and electronic flash are examples of 'cold' or bluish sources. In colder light, the warm filters must have

Control tones locally with the aid of filters. Different tones can be made lighter or darker to achieve contrast or harmony. Here, three filters have been used to demonstrate the differences that can occur. From the top: no filter, green filter, orange filter, red filter.

their factors increased, and the cold ones must have them decreased.

Exposure factors are not the only things to be altered by a change in lighting conditions. Tonal values are not quite the same either. Under warm light, for instance, a warm filter increases markedly in effect. In fact, the effect can be so strong that you may need to consider whether the content of the light is 'filter' enough, without the application of further filtering. This problem is most evident in portraiture. In either daylight or tungsten illumination, Caucasian skin tones benefit if they are darkened slightly for that healthy, sun-tanned look. This means that you should avoid using red or orange filters, because they lighten skin tone too much. Thus in daylight you might use a pale green; but under a warm tungsten light you need a cooler blue filter.

Different types of film respond in various ways to filters. Fast films tend to be more sensitive to red,

Always use filters for specific purposes. To keep a single filter in place for all pictures is to lose much of the value of filters. Examine the subject and decide whether a filter will enhance it. In this case a green filter was used to aid the tonal separation of the green leaves and green fern.

giving warm filters a greater effect. Thus, compensation with a medium yellow filter on a fast emulsion may be too much. Cooler yellow-green is much better. The green in it moves the tones back to a more acceptable level. The slower films, being in general less over-sensitive to the red end of the spectrum, respond in a more balanced way to the warmer filters. For instance in the case mentioned above the medium yellow filter is more suited.

Uses of filters

Specific filters tend to be associated with specific uses. Although a particular filter may be suitable for a variety of purposes, there may well be pitfalls. Take green filters, for instance. These are used a great deal to lighten foliage, and increase the separation between the various subtle shades of green which might otherwise be lost. However, green filters also darken the sky, so if the effect is overdone by using too strong a filter a reversal of tones will occur, the foreground foliage becoming lighter than the sky. The sky and other blue areas are also darkened with orange and red filters, dramatically so in the case of the latter. But they darken greens too; if there are large areas of both colours close together, these two completely different colours will merge as the same shade of grey. Orange and red filters are best used to exaggerate and dramatise the contrast between blue and neutral grey or yellow in juxtaposition. A good example of this is a yellow or red building standing out white against an almost black sky.

When considering the need to adjust the value of the sky, you should be aware that the degree of darkening for any given filter depends on the position of the sun. If the sun is close to the field of view, the effect will be minimal. As you move farther away to bring the sun to an angle of 90° and more, so the effect of filters is increased. Sky filters give their best when working away from the sun.

Blue filters are perhaps the most under-used. One excellent use is in portraiture under tungsten illumination, as we have seen. In addition, a blue

filter is valuable for increasing the effect of haze to enhance a mood, or to provide better tone separation between similarly-toned objects as they increase in distance from the camera. Its greatest advantage, though, is to reduce the effects of contrast; it is a useful tool for getting you out of the difficulties associated with an over-long brightness range.

One of the most useful filters is a polarising filter. With it you can create three basic effects. First, you can use it to subdue or eliminate unwanted reflections; this is the use for which it is best known. Secondly, it can reduce the effect of atmospheric haze. Thirdly, it can be used to darken the sky without altering the other tones. The reason for these effects is as follows. Light can be thought of as consisting of waves travelling out from the source. Usually the vibrations, which are at right angles to the direction of propagation, are random in orientation. When light falls on a surface their direction of travel is altered. A matt surface reflects the light in all directions, with lower intensity, having absorbed some of it in the process. However, a polished surface reflects light more or less in a single direction, producing what is called specular reflection. When the surface is non-metallic (e.g. glass or water), the reflected waves vibrate almost entirely in one direction only, and the light is said to be *polarised*.

A polarising filter transmits only light which is polarised in a particular orientation, and if the light incident on it is polarised at right angles to this direction it is completely blocked. Specular reflections can be reduced or eliminated. Thus, shop window displays can be photographed without showing annoying reflections, and highly-polished wood can be made to show its grain. Spectacles lose their unwanted reflections and show the eyes more clearly. Water can be made to vanish and the sand or stones below revealed. It is, of course, important to keep these effects under control. If the impression of the presence of water goes completely, you lose realism. It is preferable to

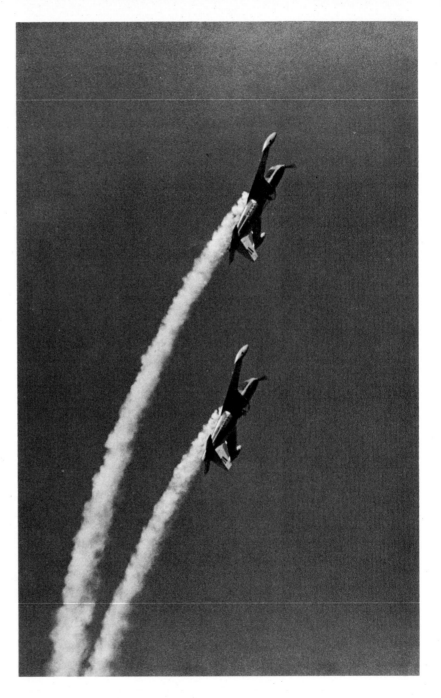

The decision whether a filter should be used must be made carefully. The shot on the left required none at all. A viewing filter showed that, because of the position of the sun in relation to the shooting angle, the sky would be dark enough.

Right: a yellow filter was chosen here, to darken the sky slightly and thus provide a better backdrop for the subject. Note that the sun was behind the photographer, and so maximised the filter's effect. *Raymond Lea.*

set the filter a few degrees away from the precise angle of polarisation, to allow a little of the reflection to remain, for effect.

Specular reflections are most strongly subdued when the light strikes the surface at an angle of 30° to 35°. At steeper or shallower angles the reflected light is only partially polarised, and the effect is less marked. In the same way, the reduction of back-scatter depends on the angle of the sun. The greatest reduction in back-scatter is when the axis of the polarising filter (which is always marked on the filter) is pointing towards the sun. Light reflected from matt surfaces or from polished metal is not polarised, and here the filter has no effect.

Haze is penetrated by a polarising filter on similar principles. Light back-scattered from droplets of water suspended in the air is to some extent polarised, and the filter will partly block this back-scatter, with the result that tonal values in the distance become sharper and clearer. Light from a clear sky is partially polarised, and the use of a polarising filter can darken the sky and increase the contrast between sky and clouds. The effect is at a maximum when the camera axis is at right angles to the direction of the sun, and the axis of polarisation of the filter should be pointed towards the sun. Thus the filter can be used for both haze suppression and sky darkening together.

Do not use a polarising filter when shooting through the windscreen or windows of a vehicle. The toughening process leaves stresses in the glass, and these affect the polarisation of light passing through them in a pattern which is clearly visible through a polarising filter. The result is dark bands or cells all over your picture.

Testing the effect of a filter

Since tonal placement is vital, it is important to know beforehand the precise effect filters will have on certain colours. As they lighten or darken values, they are really shifting them to different positions on the tone scale. You can run some simple tests to ascertain the amount of shift of each of your filters by photographing a colour-patch card, obtainable from photographic dealers. Shoot first with no filter, then with each filter in turn. Do this under a variety of lighting conditions. Then, using the filterless picture as a guide in combination with your tone ruler (see next chapter), compare the values of the various filtered shots. Write the colour of each filter and the lighting conditions on a separate piece of card, and include the appropriate card in each shot. See what happens to the tones and make a note of their new placements. You might consider making a tone ruler for the shift incurred by each filter. At the very least keep a full record so that you can make an accurate decision as to the filter required for a given effect.

An orange filter has dramatised this skyscape to just the right extent. A red filter would have darkened the sky too much in relation to the foreground silhouettes.
Michael Dobson.

Both these shots were taken with a red filter. They show how an unreal, even dreamlike, effect can be obtained from photographing an everyday scene. *Frank Peeters*.

A tone ruler

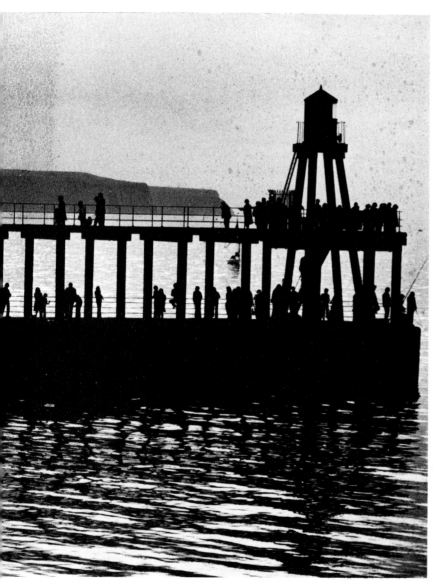

Michael Dobson

You can buy a grey scale from a photographic dealer just as you can buy an 18 per cent grey card; but you will learn a great deal more about your film and the evaluation of tones if you make your own. As it is used as a kind of gauge for exposures, it takes on the role of a measure. The vernacular for such an instrument is a tone (or zone) ruler. Which title you use depends on whether or not you embrace the Zone System. We shall call it a tone ruler here, so that if you do not want to be associated with the Zone System, you will not feel inclined to omit this useful and practical exercise. Begin by gathering around you what you need. Your camera, of course; an 18 per cent grey card; a good exposure meter, preferably separate from the camera; a white target with a discernible texture such as towelling; two films; and your favourite film developer.

Steps to mid-grey

Load a film into your camera and fix the camera on a tripod in front of the target. The target should be illuminated by a constant daylight as on a cloudless or overcast day, since tungsten lighting can alter the film's sensitivity. If you *must* work outside, expose the target in open shade rather than full sunlight, to help you to keep your exposures down to manageable levels. However, you will probably find it easier to work indoors. Use the light from the window. Set up the target below the window so that you are working towards the light. If you have it at your back, there is a real danger that you will cast your own shadow over the target and mess up the readings. Even if you avoid doing that, it is almost impossible to get an accurate measurement without your meter reading its own shadow. However, make sure your camera is low enough to avoid light entering the lens directly and causing flare. Always work with a deep lens hood in place.

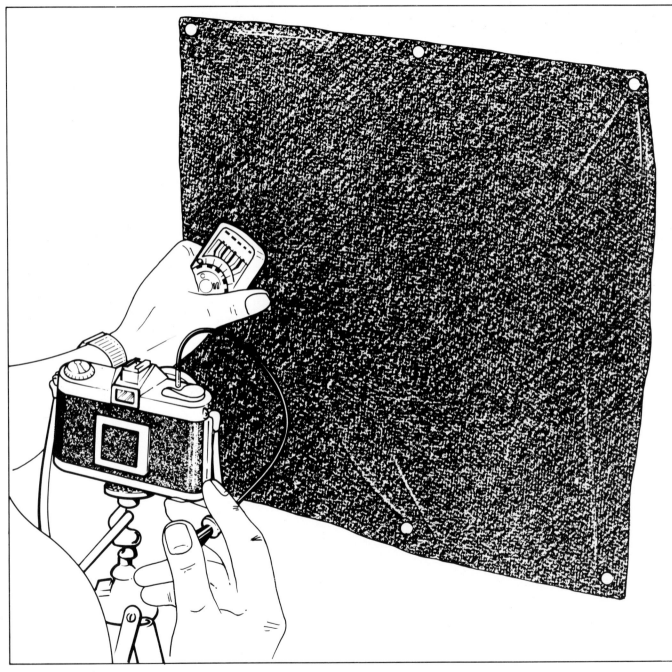

Set up your target in an area where it receives uniform light and where exposure can be controlled by aperture shifts only.

Make a direct reading from your target and transfer the settings to your camera. Do not make adjustments to return the towel to the correct shade of white. You are after a mid-grey image. Throw the towel target well out of focus, and make your first exposure. Next, bracket your exposure in half-stop intervals for up to three stops either side. Make six further exposures by opening the aperture in half-stop steps until you reach the third stop away. Repeat the process by closing down to your measured aperture, and then exposing six more times, closing down a further half stop each time.

Use only the aperture to adjust the exposure. No matter how much you paid for the camera, you cannot trust the shutter to give you absolutely accurate one-stop intervals. It is mechanical or electronic and just cannot be as precise as you expect. Only the aperture will provide the necessary accuracy. Expose the remainder of the film to ordinary subjects in the normal course of events, or expose it to Zone Vs, and develop it as you normally would. The additional exposures ensure the film will receive the same development as one of your standard films.

You can get all the information you need from a contact strip of the negatives. If you do not have a contact sheet frame, simply lay the negatives on top of a sheet of enlarging paper, and a piece of clean glass on top of that. Should your frame be the type which grips the edges, make sure the edges of the film can be seen. The whole experiment now hinges on your being able to establish the correct printing exposure. You cannot afford guesswork. Start by progressively uncovering your contact sheet in one-second steps. Use a piece of cardboard to cover it and slide it back a step at a time to make a test strip. When the job is completed, develop the paper in the usual manner.

After the paper is dry, study the edges of the film on the contact sheet. This, being clear film, is going to tell your exposure story. You should see it going through various stages of grey to black. If it is all black, then you have given too much exposure in the first place. If there are no blacks at all, you have not given sufficient exposure. Assuming that you have grey to black steps, look for the first point where you get a real black. At that point, you will notice that subsequent increased exposures make the film edge no blacker. That *first* black step is the correct exposure. Now, using the time established by this first black strip, make another contact sheet of all the negatives.

Having gone to so much trouble to find this contact exposure information, it is worthwhile recording the data. Note the aperture setting on the enlarger, the height of the head, the film, exposure, development time and paper type and grade. Then any time in the future that you use the same film type, processed in the same developer, you can simply apply all this information to set things up as they were before and make a straight contact. There will be no need to make further test strips.

Maximum black begins, and indicates the proper exposure.

Should you change the film, or the developer, a test strip is necessary to check the correct exposure.

The final step in this half of the experiment is to compare the various greys on your processed dried contact sheet with your grey card, to find one which matches. Where that happens, ascertain the stop used in relation to your metered exposure, and translate it in terms of an adjusted film speed. For example, if you find that the greys match at a stop which is one greater than your metered exposure, use the film at ISO 250/25° instead of ISO 125/22° in future.

Making a tone ruler
The second half of this experiment involves setting up your target once again. Using the same shutter speed as before, meter the target to find the aperture that will give you mid-grey. Photograph it. Then make five more exposures, closing down one stop each time, return to your starting point, and make four more, opening up one stop each time. However, you are unlikely to have that many stops on your lens! This is where working indoors has the advantage. You can adjust the volume of the light in the room simply by opening and closing curtains. Check your target with your meter as you go, and you can control the light in half- or one-stop intervals exactly.

To make the going smooth, it is best to plan in detail before you begin. Write down precisely the aperture to use at each step and then tick each one off as you shoot. That way you can be sure of making no mistakes. Your plan may look like this:

Zone V	f/8 at $\frac{1}{125}$ s
Zone IV	f/11
Zone III	f/16

Close curtains to lower the light by two stops.

Zone II	f/11
Zone I	f/16
Zone 0	Expose with lens cap on

Open curtains to raise the light level by two stops. Return to, and shoot at . . .

Zone V	f/8
Zone VI	f/5.6
Zone VII	f/4
Zone VIII	f/2.8
Zone IX	f/2

Pay particular attention to your two largest apertures. The largest one may not be a full stop away from the next one down. For instance, from f/2 to f/1.8 is only $\frac{1}{3}$ stop. A full stop from f/2 is f/1.4. If you are in any doubt, don't use the lens at full aperture.

Expose the rest of the film to any suitable subjects, or to Zone Vs as before, and process it. When it is dry, make a contact strip using the data established earlier and process using your normal technique. From the dried contact sheet, cut out the exposed frames and set them in order. Stick them on a card and mark them, for ready reference, with the zone numbers; you now have your tone ruler.

The tone ruler is the means by which you finally reach your goal of being able to see the scene in monochrome. When you can do that, you are really

After you have made a correct exposure, using maximum black techniques, compare the strip of greys with a grey card. Note where it falls. In this example, it was the third frame from the left. As the film was used at its marked speed on frame 1 (left), it proved that it was consistently being underexposed by two stops in this camera, using a standard exposure and development method. Adjustments in agitation, time, temperature, developer type or exposure, or a different camera, would produce a different result. For this experiment and for future shooting, a revised exposure index was required.

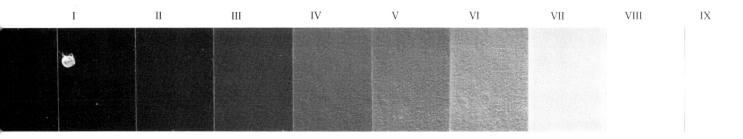

The cone rule cut and set, marked with zone numbers, and ready for use in comparing exposure readings with prospective tonal values. With this valuable aid you can learn to see subjects in shades of grey and previsualise the final print.

pre-visualising the finished print. You may feel that many successful photographers do not go to these lengths to pre-visualise tones, but if so you are wrong. Any photographer who is good in the medium knows his film intimately, and what it can do; he applies it to his subject and bends the image to his will. He does not deal in unknowns. Nor can *you* afford to do so. Once you know how the scene will appear in a black-and-white image, you can take steps to emphasise certain values for effect, or subdue others, and you can avoid tone merges, desaturation, etc. This is where the tone ruler is of great value. To use it in conjunction with your metering techniques is fascinating; indeed, it can only be described as a photographic experience. As you pinpoint specific values with your meter and study them against the ruler, the vision of your finished result becomes crystal-clear. You can accurately visualise what is going to happen to the scene in black-and-white.

Pre-visualising the picture

Find a static subject on which to try it out first, one to which you can return later and expect to find unchanged. It should have a wide range of tones, from deep shadows to bright highlights. Now pick a tone somewhere in the middle, and meter it. You know that if you photographed that value at the suggested setting, it would be mid-grey; but is that where it should be? Compare the real thing with your tone ruler and decide at which value it would intuitively appear correct on the finished print. When you have decided that, ask yourself if you really want a true representation of that value.

Perhaps it would look better a little lighter, or darker. Having decided, adjust the aperture up or down to suit. It is here that you experience a fundamental truth. You do not have to feel bound by literal translations. You can make the part of the subject in which you are interested any tone you wish. A new kind of creativity becomes apparent. Let the picture you intend to produce convey the image you want; not what it is.

When faced with the problems of interpreting values it is easy to get confused about which way the aperture goes to lighten or darken tones. To make a tone lighter on the print, you must have more density on the negative. The greater density then holds back the light from the enlarger, making the print tone paler. You get more negative density by giving more exposure. Therefore, to lighten tones, you open up the aperture from the given metered setting. Conversely, to darken values, you require less negative density to permit plenty of enlarger light to reach the printing paper. So close down the aperture.

Placing tones

The next step is to check the remaining tones. You need to find out what your personal evaluation of the tone you have just metered has done to them. Meter different values within the scene. Choose relatively important or prominent ones, and compare them with your ruler to see where they fall. If your personal decision about the first value placed it on Zone VII, and your second metering was two stops below, then you know its placement

7

8

9

10

11

For captions, see overleaf

77

is Zone V. Gradually, as you meter tone after tone in turn, you will build up a black-and-white image in your mind.

It is possible that your Zone VII anchor was too high a placement for the remainder of the tones. For instance, your deep shadow, which should be on Zone I, falls on Zone II; something which should really be Zone VIII falls on Zone IX. A compromise must be made. It is all right to choose your own value for an interesting subject, but it must not be done at the expense of the remainder of the tones, particularly where the extremes of the scale are concerned. Look again at Zone VI. Would your anchor value really look too dark if placed there? It seems as if you will have to live with it and you must open the aperture by one stop to move the Zone II shadow down to Zone I, and the Zone IX highlight down to Zone VIII. While your basic value may not be quite what you envisage, the scene overall will look a great deal better.

After developing and printing, the next step is to revise what you have done, at the scene itself. Take your finished print and the tone ruler to the scene you photographed, when conditions are more or less identical. Look the scene over and compare your print with the subject and the tone ruler. See where you have been successful and where you have made mistakes. Note how your interpretations have been translated but, more than that, pay particular attention to how the full-colour subject has transferred to black-and-white. How close was your pre-visualisation?

Some photographers chart values and their exposure interpretations, making notes as they go. As a device for a post-visualisation check it is useful in that it is a written record of what was in your mind at the time. Then the comparisons with the print and the subject have substance. To simplify the process in the field, get hold of a cheap notebook and draw up charts in advance. Then you have only to fill in the gaps. An example is shown opposite.

Captions to illustrations on pages 78–79

1 To build up a previsualised image, first find a recognisable tone to meter. The wall looks likely. A straight measurement should be fine. Place it on Zone V.

2 Now the path. That falls on Zone VIII. It seems a little high. Let's check some more.

3 That roof looks likely. Halfway between Zones VIII and IX: much too high.

4 How about this sunlit part of the wall? Zone VI. No good at all. It is above the emotional value.

5 Now think again. Go back to square one. Should that shadowed wall be on Zone V, or would Zone IV be more acceptable anyway? It definitely looks better at Zone IV.

6 That should place the path on Zone III. Much better and far more real.

7 Now, how about the roof? That should be hovering between Zones VII and VIII. Good. A little more detail will be present.

8 Now the sunlit wall will fall on Zone V, which is emotionally correct for stonework brightly lit.

9 The foliage reads Zone II. A little dark, but it is in shadow.

10 It can stay there because the sunlit church wall is just right on Zone VII.

11 Even at this setting the porch doorway falls on Zone 0. A pity, but expected. That leaves the sky: Zone VIII. There will be some tonality then. If it is filtered that will bring it down a zone – can't do that. It will merge with the church wall.

Now the picture can be seen (opposite).

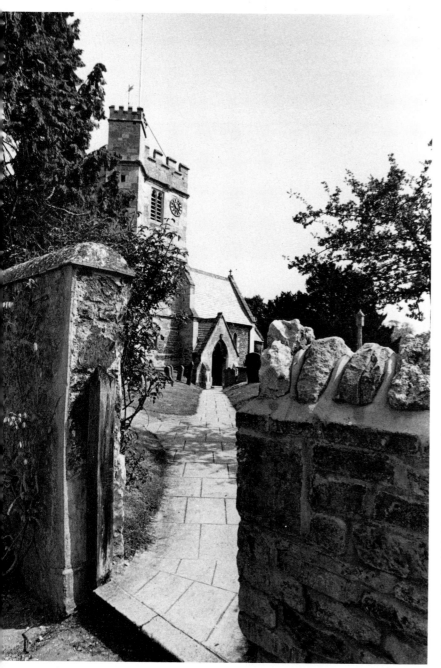

Exposure record chart

subject	village church
zone 0	porch doorway
zone I	
zone II	foliage
zone III	
zone IV	shadowed wall
zone V	sunlit wall
zone VI	
zone VII	path
zone VIII	sky
zone IX	
stop range	7
aperture	f/8
speed	1/125 second
notes	bright sun; anchor value = stonework + 1

The amount you will learn from a close examination such as this is considerable. It may seem long-winded now, but we are learning, and to get the principles firmly rooted will take time. The important thing is that you will learn a great deal about the monochrome process; this knowledge will increase with each post-visualisation study. With practice the number of meter checks you have to make will diminish. You will see where certain values are just by looking at the subject. As a consequence, the entire routine of determining exposure will speed up.

Recognising that you can make any subject the grey you choose, there are some fundamental values which give true subjective representations. In other words, they are acceptable to the eye when positioned at specific points on the scale. A number of them are listed on page 83. It is not an exhaustive listing by any means. There are two reasons for this. First, it would need several volumes to account for every subject under the sun, or indeed any other kind of light. Second, photography is a personal

Sometimes it is necessary to adjust the measurements. The shadows in this backlit scene should fall on Zone IV–V. However, the sheer drama of the scene suffered as a result. Tests were made, placing them on Zones III and II. A final print revealed the Zone III shadows produced the preconceived effect, as print 2 demonstrates.

1

2

3

Although the natural anchor reading for a human figure is the skin, in this case it was difficult. Therefore the jumper was chosen as the anchor, and left on Zone V. This placed the white-painted face on Zone VIII.

thing. In no way should you be pinned down to a specific formula. A good picture is made by your own interpretation of the subject; that means you should be able to adjust any single value according to your judgment. However, while you are learning it is useful to have a guide.

subject	zone	subject	zone
black clothes	III	white skin	VI
building shadow	IV	stone in shade	V
bright colours	VII	sky	VIII
creases & folds	III	sea	IV–V
concrete in overcast	VI	sand	V–VI
concrete in sun	VII	snow in full sun	VIII
chrome	IX	snow, side-lit	VII
clouds	X	snow in shadow	VI
clear blue sky	V–VI	shadows in dim light	I
dark stone	IV	sunburned skin	IV
dark skin	V	shadowed object in snow	III
forest depths	I	stone, dark	IV
foliage, dark	IV	stone, light	V
facial shadow	IV	skin, very light	VII
foliage, light	V	skin highlights	VIII
foam (sea)	VII–VIII	specular reflection	IX–X
grey stone	V	sea foam	VII–VIII
glaring surfaces	VIII	textured shadows	III
glaring white surfaces	IX	tree trunks	IV
highlights on skin	VIII	tree trunks in shade	III
highlights	IX	twilight scene, foreground	III
leather	III	unlit rooms	I
landscape shadow	IV	weathered wood	V
light foliage	V	whites without textures	VIII
light stone	VI	whites with textures	VII
light skin	VII	whites, glaring	IX
light grey concrete	VII	water highlights	IX
moon	VII	water foam	VII–VIII
openings to unlit rooms	0	water, muddy	IV
portrait shadow	IV	water, clear	V–VI

It is important to realize that tones or zones are not sacrosanct. We have already seen the occasional need for compromise. Remember that there are situations where their true values can be shifted a little. Cast your mind back, for instance, to our manipulations of a backlit subject. Even though the Zone System has a mechanical feel about it at first glance, this is not really so. As with every other system, it works best if adopted and adapted to your personal creative will.

Film development

We have already observed that exposure and development are closely linked. The time has come to establish the reasons and to examine something of the background to the linkage.

Exposure and development cause the film to respond in two seemingly different ways: exposure determines density; development determines contrast. The first is not too difficult to appreciate. The greater the amount of exposure we give to a scene, the denser overall the negative becomes. More light has been allowed to reach it and a larger overall number of silver halide particles have been affected. That development determines contrast is not quite so obvious. To begin with, in a scene the light/shadow relationships determine contrast. The extent of the brightness range, as we discovered in the chapter on exposure, tells you just how contrasty a scene is. Seven stops, or a ratio of 128 : 1, is ideal. 1000 : 1 is too contrasty, and 32 : 1 is too flat. However, the principle of contrast and development was touched on in the chapter on precision metering. To put them into context, it might be a good idea to recall what happens during development.

During exposure the emulsion absorbs light energy. It consists of millions of microscopic particles of silver halide suspended in gelatin. The light energy is absorbed by these particles in proportion to the intensity of the light, forming a *latent image*. The change is not visible to the eye, hence the term 'latent'. When the film is immersed in a developing solution, all those particles which bear a latent image are reduced to metallic silver, which looks black because it is in the form of tangled filaments, or *grains*, which absorb light. The optical image which falls on the film has a variety of intensities, corresponding to the lights and darks of the subject, and the emulsion records these in terms of the

latent image, the brightest parts of the scene affecting most particles and the darkest parts the fewest. On development the brightest parts of the subject record as the darkest parts of the negative, and vice versa.

Developers

The term 'amount of development' covers more than just time. There are two other important factors: the composition of the developer, and its temperature. The former we shall deal with later. All chemical reactions proceed at a faster rate if the temperature is raised, and development is no exception. All manufacturers of developers put out time-and-temperature charts with their products, and you should always refer to these. The normal temperature for development is 20 °C for black-and-white materials (for colour materials it is usually higher).

It has recently become common practice to use negative developers in a diluted condition. This has the obvious advantage that you can use a developer just once and then throw it away, without prohibitive expense, and do not have to worry about progressive exhaustion with repeated use; but it has another, less obvious advantage.

Clearly, diluted solutions work more slowly than concentrated ones, and this gives you a way of coping with excessive contrast in the subject. It is not just a matter of slower development, however; there is a further effect. When the weakened developer comes into contact with a highlight area it has too much work to do, and it quickly becomes exhausted. Development then ceases until agitation of the bath again brings fresh developer into contact with the area. On the other hand, the developer has little work to do in the shadow areas, and does not become exhausted. The overall effect is that the highlight areas tend to be held back while the shadow areas are built up. The overall contrast is lessened without the penalty of loss of emulsion speed that is incurred when a negative is deliberately underdeveloped to reduce contrast.

86

The method is known as *compensation development*.

The anatomy of a developer

Although there are differences of detail, all developers contain basically similar constituents.

1 Developing agent This does the basic work of converting the exposed particles of silver halide into grains of metallic silver. The important thing about a developing agent is that it must reduce a

Left: a high-contrast scene, such as a subject close to a window, demands special treatment during development. One way of coping is to use compensation development, at high dilution. This has the effect of holding back the highlights while building up the shadows, resulting in a more manageable negative contrast.

For the photograph on the right, taken on an overcast day, straightforward development of a medium-speed emulsion produced the level of contrast and tonal separation required by the subject. *Raymond Lea.*

particle to silver if, and only if, it bears a latent image. Most developing agents are used in pairs, for example metol-hydroquinone and Phenidone-hydroquinone.

2 Preservative Solutions of developing agents absorb atmospheric oxygen and quickly become useless if unprotected. Sodium sulphite is the most common preservative.

3 Alkali The products of development include acid substances; in general developing agents will not operate in acid solution. The most common alkalis used in developers, in decreasing order of alkalinity, are sodium hydroxide, sodium carbonate, sodium metaborate (Kodalk) and borax. Sodium sulphite is weakly alkaline, and sometimes does duty for both preservative and alkali. In general, the more alkaline the developer, the more energetic its action.

4 Restrainer Energetic developers tend to attack unexposed halide particles, producing fog. The restrainer minimises this effect. Potassium bromide is a common restrainer; in developers containing phenidone it is more usual to use organic antifoggants such as benzotriazole. Low-energy developers do not in general need restrainers.

5 Solvent Not to be forgotten! Usually tap-water, of course, although some developers demand distilled or de-ionised water.

By using different chemical components in each category, and by mixing them in different proportions, it is possible to modify the effects on the emulsion. Developers fall into six main categories:

1 M-Q or P-Q developers The developing agents are metol and hydroquinone and Phenidone and hydroquinone respectively (the 'Q' stands for 'quinol', an alternative name for hydroquinone). Together they complement each other to produce a quality of image not possible when they are used separately. They are used for general-purpose work, their relative proportions determining the results. Although the picture is in fact more complex, metol and Phenidone can be thought of as being responsible for the shadow detail, whilst the hydroquinone looks after the contrast.

2 Special fine-grain developers These use low-energy developing agents in a weakly alkaline solution to reduce clumping of the halide particles. Ultra-fine-grain developers contain silver halide solvents such as potassium thiocyanate. In producing fine grain, the developer also lowers image contrast and emulsion speed, sometimes by as much as two stops.

3 High-energy developers These developers are concentrated and have a high alkalinity. They give maximum contrast and emulsion speed at the expense of high graininess. Processing times are often surprisingly short, and may be at temperatures higher than normal; they are useful for rescuing accidentally-underexposed negatives, or where a grainy effect is desired for pictorial reasons.

4 Compensating developers These are highly diluted soft-working developers designed specifically for thin-emulsion films, which tend to be inherently contrasty. The principle is as described above.

5 Acutance or high-definition developers Also designed for slow thin-emulsion films, these developers accentuate the *adjacency effect*, whereby developer becomes quickly exhausted in highlight regions. Fresh developer diffusing in from adjacent shadow regions boosts the developing action at the edges of the darker areas, effectively sharpening up the edges and increasing acutance. As these developers depend on the build-up of restraining compounds for their action, they can be used once only before discarding.

The combination of a fast emulsion and a standard M-Q developer can produce a full tone range and excellent definition, even with this kind of candid shot taken with a 135 mm lens. *Brian Sutton.*

An MQ or PQ developer produces grain fine enough and detail sharp enough for most general-purpose work. It has the advantage of exploiting the full tonal scale of the negative to give a wide latitude and makes printing easier.

6 Contrast developers These are special-purpose developers designed for large-format specialist work such as X-ray and photographic reconnaissance. They give high contrast, maximum film speed, and lots of grain. This type of developer is also used for line and lithographic negatives which are required to be clear-and-opaque, with no intermediate tones.

The characteristic curve

As might be expected, scientists and technologists have reduced the business of exposure and development to figures; the study of the behaviour of photographic emulsions in objective terms is called *sensitometry*. Most of the data of sensitometry are expressed in graphical form. The most important graph is the one which connects exposure with the blackness or *density* of the resultant negative; it is known as the *characteristic curve*. The horizontal axis of the graph represents the exposure (strictly, the logarithm of the exposure, but if you have an aversion to

mathematics, don't worry about this detail). The vertical axis represents density, which is a measurement closely correlated with blackness, so we can think of it in those terms. Both of these scales can be represented by a scale of greys, one in the subject, the other in the negative.

The characteristic curve falls broadly into three portions. The *toe* is the lowest region, where it takes quite a large variation of light to produce a small difference in density. Photographers think of it as the 'region of underexposure'. Next comes a region where the curve is fairly near to being a straight line. In this region the blackness of the negative is almost exactly proportional to the brightness of the subject, so it is known as the linear, or 'straight-line' portion. This is the 'region of correct exposure'. The uppermost region again becomes non-linear, and is called the *shoulder* or 'region of gross overexposure'. With general-purpose amateur films it is almost impossible to reach this region unless there is

something seriously wrong with your camera shutter; but with slow thin-emulsion films it can certainly be reached. Eventually we reach a point where *all* the silver halide particles bear a latent image, the region of *maximum black*; in this region no amount of further exposure will make any difference to the density. However, long before this point is reached, the highlights begin to become blocked up. This means that in cases of overexposure the middle and higher tones also begin to become blocked up. At the opposite end of the scale, underexposure puts the lower middle tones onto the toe region, where the contrast is excessively low; this is why underexposed negatives give prints that are lacking in contrast in the darker tones, with muddy, poorly separated shadow detail.

Contrast is indicated in the characteristic curve by the steepness of the straight-line portion. If this is shallow it delineates a negative of low contrast; if steep, one of high contrast. The slope of the curve bears the name *gamma*. Gamma is a somewhat limited quantity; for one thing modern emulsions do not have much of a straight-line region at all; for another, it has been found that the best-quality prints are made from negatives which utilise a fair portion of the toe region.

Different film speeds have different shapes of characteristic curves, and this is particularly noticeable in the toe region. Slow films tend to have long toes which rise abruptly into the straight-line portion; faster emulsions have a gentler sweep. Slower emulsions are in general much more contrasty than faster emulsions, so that to produce the same value of gamma with a given developer it may be necessary to use widely-differing processing conditions. Even so, while the gamma may be the same, the negatives certainly are not. They usually require different paper grades to achieve an acceptable print. Because of all these discrepancies, a new system has been devised which embraces these variations in both toe and shoulder (or 'elbow') regions. It is called the contrast index.

Contrast index

This method takes into consideration the lowest useful density on the toe, and the highest useful density. A straight line is drawn joining these two points. This has the advantage that negatives developed to the same contrast index actually do have the same contrast. You can now produce negatives from any type of film to print on a given grade of paper. What is more, if you are using a new film or a new developer for the first time, you can process films to a known contrast and get predictable results.

Nowadays most films and developers are accompanied by contrast-index graphs, which can prove extremely useful to the enlightened enthusiast. Contrast, in the contrast index graph, is achieved by developing for a certain time, read off from the graph. An average value for contrast index would be 0.6. However, not everyone's equipment and techniques are the same. Even at the same contrast index the differences can produce markedly diverse effects; you should therefore take the figure as a guide only. Try it first and see what results you get.

For example, if your negatives lack contrast, check your equipment. Perhaps your camera lens filters are elderly or scratched. Your lens itself could be in a similar condition. Either of these could cause flare and a loss of contrast. Consider your enlarger illumination too. Misalignment of the optics or a dirty lens will affect contrast adversely. Look for stray light in your darkroom, particularly from the enlarger itself. Or your contrast may be higher than you expected; this can come from the optics of a condenser enlarger, which tend to increase image contrast (see page 146).

The important fact to accept is that a contrast index of 0.6 may not be exactly right for your overall photographic system. Check right through this, and modify your processing techniques accordingly. Once you have got things right, you can develop any film you like, in any developer your like, to

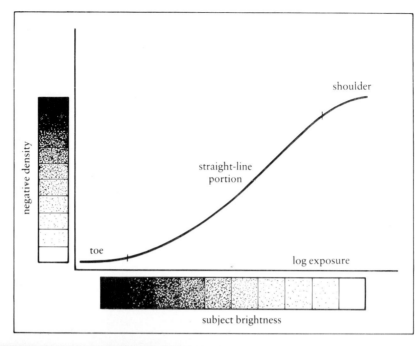

straight-line
portion

shoulder

toe

negative density

log exposure

subject brightness

It is within the straight-line portion of the curve that the bulk of most photographic images should be contained.

Because modern general-purpose emulsions have no significant straight-line region, and because the best print quality is obtained when part of the negative density range lies on the characteristic curve, a contrast index figure is obtained for a hypothetical average subject. A special matrix is laid on the characteristic curve; the contrast index is the slope of the line joining the lowest and highest densities.

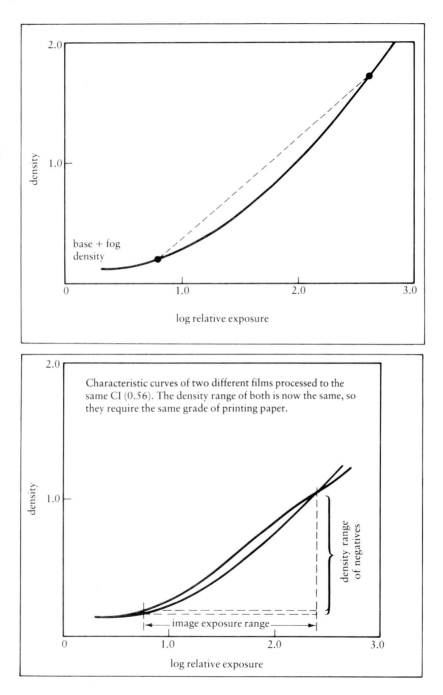

base + fog density

Characteristic curves of two different films processed to the same CI (0.56). The density range of both is now the same, so they require the same grade of printing paper.

density range of negatives

image exposure range

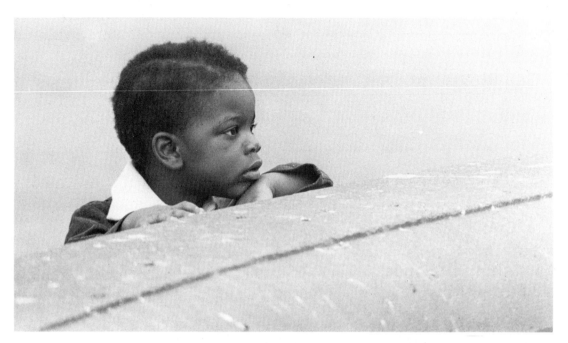

For a low-contrast scene, it is necessary to develop to a higher CI than normal. As the brightness ratio of the original scene was only 32:1, or five stops, the CI chosen to redress the balance was 0.90.

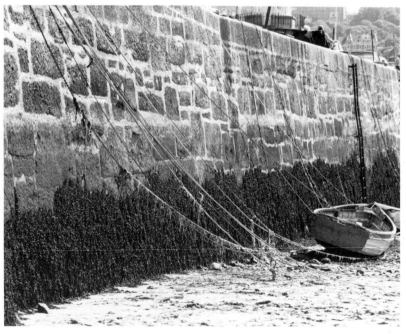

High-contrast scenes demand processing to a lower contrast index. Here, the brightness range covered eight stops, giving a ratio of 256:1. The film was therefore developed to a contrast index of 0.50.

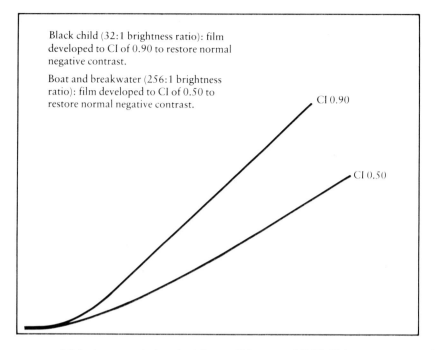

Black child (32:1 brightness ratio): film developed to CI of 0.90 to restore normal negative contrast.

Boat and breakwater (256:1 brightness ratio): film developed to CI of 0.50 to restore normal negative contrast.

CI 0.90

CI 0.50

your established contrast index. And there will be no more headaches.

Processing steps

Modern processing is achieved by a sort of remote control, using the time-and-temperature method. It is necessary to work precisely in order to achieve consistent results. It is vital then, that you establish a rigorous routine. It is quite possible that you have such a routine already. If you are certain that it gives consistent negative contrast and density, you can skip this section. Should any uncertainty exist, try this method out.

1 Prepare all chemicals to the correct dilution. Remember that dilution influences contrast. You cannot be too careful about mixing and making up developers; get it absolutely right.

2 Bring all chemicals to the correct temperature. Again, this has an effect on contrast and density. The most commonly used temperature is 20 °C

(68 °F). If the temperature is higher or lower than this, development must be cut back or extended respectively. However, it is equally important that all the baths through which the film will pass are at the same temperature. If there is a marked difference, you stand a good chance of destroying all your good work.

3 Pre-soak. Pour in the right amount of water at the correct temperature, rap the tank sharply on the table to dislodge any airbells, and begin agitation. The airbells, if allowed to remain, would prevent the liquid from reaching all parts of the film and cause uneven development. The idea of the pre-soak is to bring film and tank to the proper temperature, so that the developer will not be cooled down when poured in. It also serves to remove dust and reduce the risk of airbells in the developer. Agitate the pre-soak for one minute, then pour it away. Agitation is used to keep fresh chemicals in contact with the film at regular intervals. It is not so critical during the pre-soak,

but in development and fixation the bath can become exhausted quite rapidly in the vicinity of the film. A favourite method is to invert the tank and then right it again. There are others: rotating the spiral, 'swilling' the solution around in the tank, lifting and immersing, and so on; but the inversion method is by far the most popular and reliable. Inverting the tank ensures a constant and even flow of solution over all parts of the film. Regardless of the method you choose, agitation should be gentle. True, you are only running a liquid over the film, but should you overdo the agitation you run the risk of damaging the emulsion.

4 Development. Pour in the developer at the correct temperature. As you pour the chemical in, set the clock. Agitation must be regular throughout development. A sound and consistent method is to agitate continuously for the first 30 seconds, followed by a five-second agitation, 30 seconds later, then a further five-second agitation every minute thereafter. By keeping agitation consistent you will also get results that are consistent. If this method does not suit you, it is important to make sure the timings between agitations are at reasonably short intervals. If too much time elapses between them, there is a risk of uneven development; if you agitate continuously, you may overdevelop the film. Pour away the developer as the time expires. The last drop should coincide with the expiry time, if possible to within a few seconds.

5 Stopbath. A 2 per cent solution of acetic acid halts development immediately by neutralising the alkali in the developer. Agitation should be continuous for one minute.

6 Fixation. Replace the stopbath by the fixer. This chemical converts the undeveloped silver halides into a soluble form which can be washed away in the next step. If they were allowed to remain, they would become exposed in the light and slowly turn the remainder of the negative black. Intermittent agitation as described for development will do nicely, until the time is up. Such meticulous

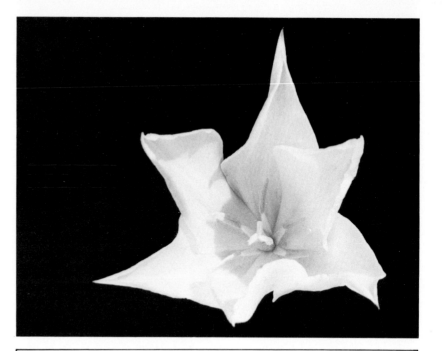

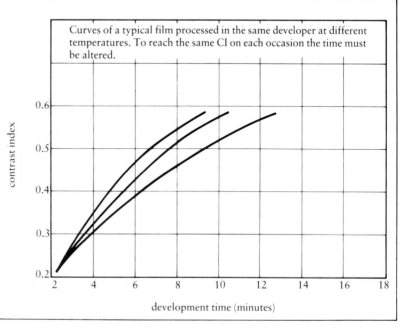

Curves of a typical film processed in the same developer at different temperatures. To reach the same CI on each occasion the time must be altered.

Where tonal placements have to be precise in order to maintain their proper values, only consistent technique can maintain a standard. Strict control over developer dilution, time, temperature and agitation is the only way. Mistakes can often be costly, destroying the delicate detail and light/shadow transitions in pictures such as these.

agitation is not essential here, but is good practice. Pour the fixer away at the completion of the step and open the tank lid.

7 Wash. If you can maintain a temperature of 20 °C with running water, use it to wash the film. This step will need 15 minutes minimum. Do not let the jet of water play directly on the emulsion. If the water is very cold, use frequent changes of water at the correct temperature instead. Change the water every five seconds or so for the first minute. At the end of this time most of the chemicals will have been washed away, and thereafter you need only about one or two changes a minute, until the full washing time is completed.

8 Wetting agent. Add two drops to the final rinse, and remove the spiral after a few seconds of agitation. Shake it to get rid of surplus solution.

9 Drying. The preferred method is to use a drying cabinet, otherwise any warm unoccupied room will

do. Drying can be speeded up and the risk of drying marks minimised if you wipe the film down gently with a soft, clean chamois leather or a well-wrung-out cellulose sponge. Don't be too enthusiastic or you may damage the tender emulsion. Above all, don't use squeegee tongs, as if they have picked up any dirt they will score the film for its entire length.

10 Storing. Cut the dry film into strips and store in negative envelopes or file in a negative album. Protection of your negatives is of the utmost importance, and careful handling at all stages up to and including storage is mandatory.

Film development may seem to be in a way mechanistic; silver halides are reduced to metallic silver by impersonal chemicals. A prescribed combination of time, temperature, dilution and agitation produces film after film of correct contrast and density. But even these mechanics can be bent and shaped by your creative will. We said earlier that exposure determines density and development determines contrast; now substitute the word 'controls'. You can manipulate both to control the quality of the final negative.

Now let us get something straight: a film will give of its best only when exposed and developed correctly. A scene with an average brightness range of 128 : 1 (seven stops) can then be reproduced with a good range of tones, which correspond in density to the reflections from various parts of the image. Under these circumstances, the contrast index will be around 0.60 for normal negative contrast.

Ultimate control

Consider the effect of abnormally high or low subject contrast on a negative which has been processed for the standard time. In a high-contrast situation, either the deeper shadows, or brighter highlights, or both, drop off the ends of the characteristic curve, making them solid black or blank white respectively. In neither extreme can you expect to see detail. Conversely, if the

97

brightness range is short, the contrast of the negative is low. There is too much latitude on the film this time, and the short brightness range can be fitted within it at almost any point. The negative and print will be flat and lack the full range of tones that makes a picture with a punch.

When faced with such situations, the standard practice is to manipulate the contrast at the printing end of the process. For hard, contrasty negatives, you use the softer paper grades. Extended range papers such as Grades 1 and 0 should cope with the job. For the flat negative, you would resort to Grade 3, 4, or even 5. However, although such action will rescue your images in an emergency, contrast control by selecting a different grade of paper should be used only as a last resort. You can only produce optimum results if you use a normal paper grade (2) with a normal (contrast index 0.60) negative.

It is only fair to say that there are exceptions. Some photographers prefer to manipulate things so their printing grade is 3 rather than 2. The results they get are excellent. But that is because they control the contrast at a less troublesome stage, namely the negative. There are two more or less fixed limitations. There is the brightness range of the scene on the one hand. You just have to accept what is there. On some subjects the small lighting adjustments you can make help, but for outdoor photography you have little or no control. Different grades of paper give some flexibility; but if, as suggested, you have decided to stick to a single grade of paper, these fixed quantities mean that the only room for freedom is in the processing of the negative.

This is where the contrast index comes in. Knowing that 0.60 is about normal for the 128 : 1 contrast ratio subject, we have only to lower it for a high-contrast subject, or raise it for a low-contrast one. The question is, how much? We find the answer at the exposure-measurement end. Remember the technique for checking the

17

Both these situations, the low contrast in the picture of the statue head and the high contrast in the image of the aircraft, demand absolute control over development if the correct tonal relationships are to be retained. However, because such images are often on a film containing many other contrasts, compromises are in order.

brightness range? First measure the deepest shadow in which you want to show detail, and make a note of the reading. Now measure the brightest highlight where detail is important and count the number of stops it is away from your shadow reading, including those measured. Now that you have information about the contrast in terms of stops, the next step is to relate it to a contrast index figure. If you can find a suitable one, you can control the contrast in the negative and bring it back to the ideal seven-stop range for a straight print on Grade 2 paper.

The nomograph reproduced here will help you. It is quite easy to use. Find the number of stops in the left-hand column which represents the contrast you have just metered. Lay a rule on it and pivot it until the rule joins up with the mark in the centre column. The contrast index to which you should develop your film to return it to the standard seven-stop range is then found adjacent to the rule in the right-hand column. It should be stressed that these figures are only averages of those required for specified contrasts on slow, medium, and fast films. You may find that, like the need to find your own personal contrast index figure, you will also have to experiment with these. Nevertheless, they do give you a starting point. In most cases, the adjustment can be pre-determined. If you are aware of your 'personal' contrast index, simply adjust the chart, and the others will fall into line. Let us say that a figure of 0.53 is correct for you. Place your rule on the 7 mark in the left-hand column, and on the 0.53 mark in the right-hand column. Where it crosses the centre column, make your own mark. Now, any future adjustments can be worked out by always using your new centre control mark.

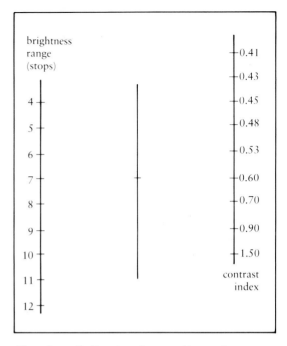

If you have the literature for your film(s), this should give you time alterations for development in order to produce various contrast indices. Should you have no figures available, a good reference to turn to is the Compact Photo Lab Index (Morgan & Morgan), which contains all the information you need with regard to matters both of this kind and a host of others. Of course, you can make your own experiments to find out. This is always favourable because then the answers are highly personal. To point you in the right direction, use the table below as a basis. All you have to do is to increase or decrease the development time by the percentages listed here and then fine-tune as you see your results. 'Image contrast factor' refers to the brightness range that existed at the time of shooting. 'N' stands for your normal development time for the contrast index that suits you best.

The real problem with the Zone System (or, indeed, with any other contrast control system) is that if you are working with 35 mm or rollfilm each film

image contrast factor	3	4	5	6	7	8	9	10	11	12
fast film (%)	+100	+75	+50	+25	N	−10	−25	−35	−45	−50
medium-speed film (%)	+85	+60	+45	+20	N	−10	−20	−30	−40	−45

may contain many different exposures of subjects that may contain great variations in contrast. Negative contrast control works best with sheet films, where you can develop each film specifically to the correct contrast. With 35 mm or rollfilm you may shoot only one or two frames of a subject with precisely 128 : 1 contrast. So you are forced to make compromises, as the values on the charts are appropriate only to films in which every exposure has been made under the same conditions. In this case you should work out the best processing technique and contrast index for the majority of the shots, getting the remainder right at the printing stage (see pages 144–148).

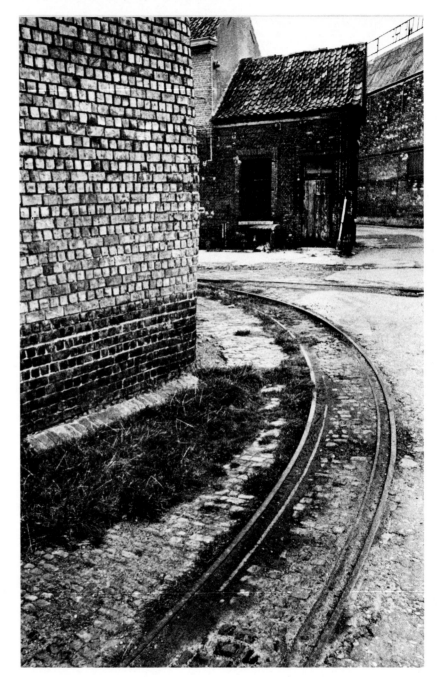

Speed-pushing by rating Tri-X at ISO 1600/33° (near right) has produced a crisp, only slightly grainy effect quite unlike the soft-focus image obtained by photographing through a diffusing screen (far right). *Frank Peeters; Carlos Scheurweg.*

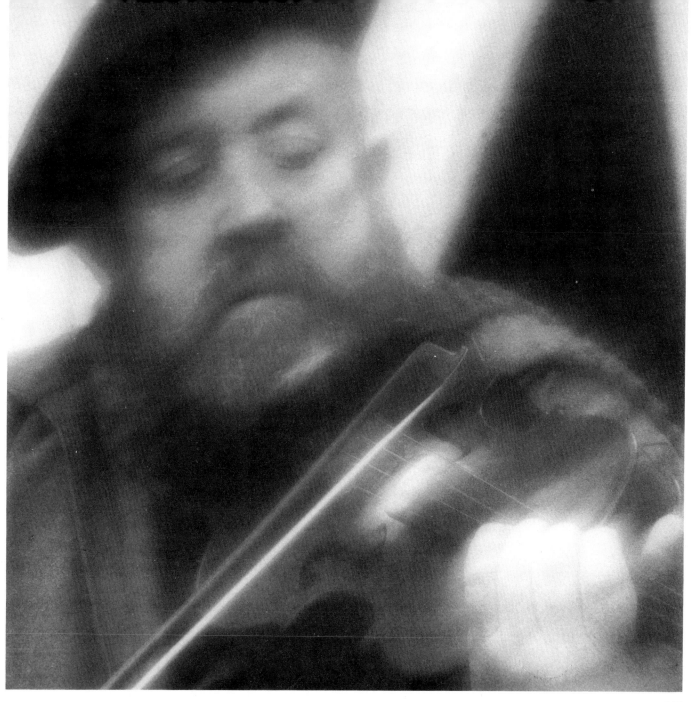

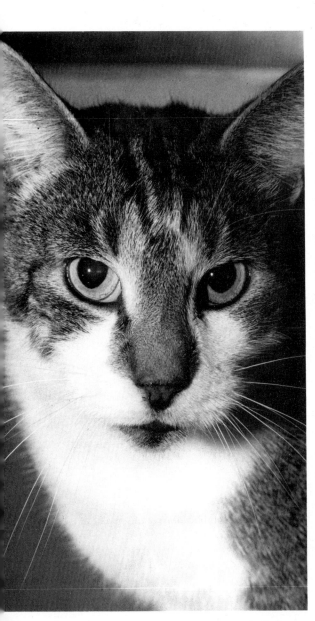

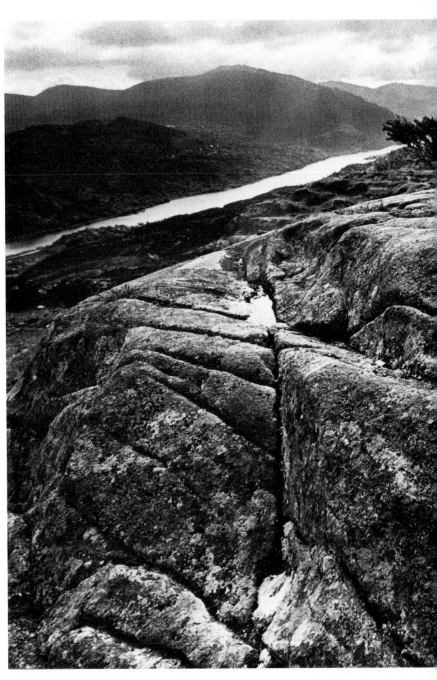

102

Tone control

If you underdevelop to adjust contrast downwards, the negative is going to be on the thin side. It has not had as much processing time as it should have had, and therefore individual tones do not have sufficient density. In addition, as mentioned earlier, tonal separation of the lower values suffers. Conversely, overdevelopment produces a denser negative than normal, possibly with blocked-up highlights. Exposure adjustments are the answer. When you have discovered the brightness ratio in terms of stops, and decided on the development required to redress the imbalance in contrast, this determines whether or not overall exposure adjustments are necessary. Thus you would increase the exposure for underdevelopment. This keeps overall density at the right level and ensures good tonal separation of the lower values. For overdevelopment, you would reduce the exposure to control the otherwise excessive density, and prevent saturation of the higher values.

Exposure manipulation always results in shifts in tone. The image is pushed down the characteristic curve by underexposure, and upwards by overexposure. Changing the development time has only a limited effect on this. If the adjustment goes too far, the range of tones of the image may well reach into the toe and shoulder regions respectively. In terms of the tonal scale, the values on the negative are altered and do not correspond to the subjective values in the original scene.

Tone and exposure
Now consider the implications of this. You can expect mid-grey (Zone V) to remain mid-grey on both the negative and print only if you expose the film at the settings suggested by the meter. Overexpose it by one stop, and the resulting extra density shifts it up to Zone VI. The next tone down, which should have been a Zone IV, then becomes

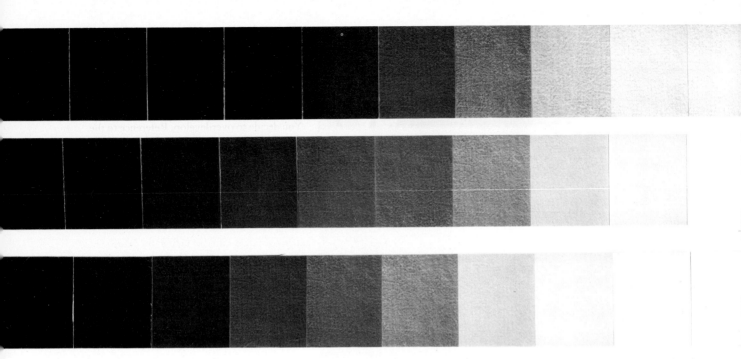

mid-grey (Zone V). If, on the other hand, you underexpose Zone V by one stop, you shift the density down so that it becomes Zone IV. The former Zone VI then become Zone V. For example, apply this to the human face. If you underexpose you get the subjective value of weathered wood. If you overexpose, it looks like snow.

Take particular note of the effects of over-, normal, and underexposure on the three grey scales reproduced here. (Because of the limitations of the reproduction process, the subtler effects do not show up; but the general message is clear.) Note how exposure shifts produce completely different sets of values. Mid-grey shifts dramatically, along with the other mid-values. The low values merge in underexposure, and the high values block up in overexposure. Naturally, you can alter the appearance of the mid-values during printing. You have only to increase the enlarging exposure time to darken a value which is too light, and vice versa. However, this aggravates the situation at the ends

of the scale. In the first instance, the highlights get too much exposure and record as grey instead of white, and the lower values lose their individuality, merging with one another to record more or less uniformly. Under a reduced exposure to lighten a middle value that would otherwise be too dark, the lower tones, instead of being rich blacks, are grey. The highlights have not had sufficient exposure time to 'burn in' detail and are thus washed out.

Tone and development
It all sounds a bit depressing, but the situation is still in hand. Remember that changes in development technique can also be used to shift tone values. Thus if a certain amount of development for a specific exposure produces a mid-grey in one area, more or less development will respectively increase or decrease the density in the negative. That same tone then appears on the print as respectively lighter or darker. But compensate underdevelopment with overexposure and the other way round, and you can go some way

Comparative results of under-, normal and overexposure.

104

In this subject the measured contrast was one stop too low. The nomograph indicated an increase in development time of 20 per cent. To counterbalance this, exposure was reduced by one stop. Tests then showed that an increase in development time (at the new exposure) of 30 per cent over the original time would produce a satisfactory range of tone.

towards putting the tone back to where it should be. One cancels the other. Moreover, development controls for contrast are still valid because they are not affected by exposure manipulations. All of this can be of great value to you if you can manage your technique to the extent that you know exactly how much difference each manipulation will make to a tone. You know what happens to values during exposure because you have your tone ruler to refer

to. But if you then take pot luck during development, all your precise work will have been in vain.

Let us use an example. Charged with the task of photographing the texture of a knotted tree trunk, you find that the contrast is too low by one stop, You decide to overdevelop. Reference to the two-zone nomograph suggests that a contrast index of 0.70 would be in order, or a development increase of 20 per cent. To lower the overall density and to bring the tree back to its proper Zone IV value, you opt to underexpose by one stop. Having made some tests, you now discover that a one-tone zone shift is effected by 30 per cent overdevelopment, but with a 10 per cent discrepancy. This is small enough to be ignored. Photography is in any case full of compromises.

To summarise: a single tone, which would otherwise have been too dark as a result of underexposure, can be restored to its correct value by prolonging the development. At the same time, contrast is increased. Conversely, a tone which would otherwise have been too light as a result of overexposure can be restored to its correct value by curtailing the development. At the same time, contrast is decreased. However, this control is only possible if the deviation from normal exposure does not exceed one (or at the most two) stops.

More tone rulers
In order to achieve the required precision you must find out for yourself how much over- and underdevelopment will shift the values in a negative in exactly one-stop steps. Again, this is something which cannot be laid down in universal rules because individual equipment and techniques vary. The way to find out your individual requirements is to make more tone rulers. This time, however, these are designed to show you the effects of development. Complete instructions for procedure are detailed in the next chapter. Once you have undertaken the experiments and come face-to-face with a contrast-control situation, you will know

how much development to give and how much exposure compensation is necessary – all before you actually press the shutter-release button.

The problems of concentrating on the mid-values with exposure and development control now become evident. We already know that under- and overexposure can cause tones to bunch up at one end or the other of the characteristic curve. Even though you may compensate during processing, the situation will be far from optimum. You must turn to one more device to control over-dense highlights, namely developer dilution. As we have learned, dilution of the developer has greatest influence on the darker tones; thus when you use a highly dilute developer you can extend or contract those highlights at will. The latitude available to you depends entirely on the amount of dilution.

For example, take three different concentrations: full strength, 1 : 2 (i.e. one part developer to two parts water), and 1 : 4. We can examine what happens in each case to the higher densities. Full strength places Zone V where it should be, and the uppermost value on the scale (Zone IV) four stops away. If, however, the measured value of Zone IX happens to be *five* stops away (in effect Zone X) from the part of the image you wish to be Zone V, you must use the 1 : 2 dilution. This shifts the upper values down by one stop, moving your measured Zone X to Zone IX on the negative. Should the upper value in which you want to show detail be effectively Zone XI, you need a 1 : 4 dilution. This shifts the upper values down two stops, moving your measured Zone XI to the new Zone IX on the negative.

Make a tone ruler for every control device at your disposal. Have them all on hand so you can refer to them to find a way out of any difficult corner. They provide a visual means of deciding which course to take. In each case, you will see the truth of the old adage to expose for the shadows and develop for the highlights. You must have sufficient shadow detail on the negative in the first place for it to

Left: at times it is important to maintain the lower values where you have placed them and manipulate only the higher values. Where the contrast is high, this means that you want to bring the higher values down to a manageable level. Underdevelopment affects all the tones, so the only answer is compensation development.

appear on the print. But when the contrast situation is such that the highlights would be otherwise too dense, you can refer to one of your tone rulers to find out how to bring them back to normal.

To summarise, then: you have three means of extending or shrinking the contrast in a negative to fit it comfortably within the apparently immovable walls of subject contrast and paper grade.
(1) Development time: highlights are affected most, middle and lower tones progressively less.
(2) Exposure/development: mid-values stay more or less where they are, but high and low values are affected. (3) Developer dilution: considerable change in the highlights, with progressively less change the farther down the scale you go.

Now set to work. Study the methods for making development tone rulers which follow, and provide yourself with a visual guide of how to effect precision tone control.

Your personal emulsion speed
The Zone System is more than a unified method of exposure, development and printing technique for black-and-white pictures. It is certainly unified; in fact, 'unified' is a key word. Exposure is related to the subject matter, and your interpretation of it; your film development is related to the exposure and the conditions of contrast existing at the time of exposure; and your printing procedures are related to the treatment accorded to the negative during the other two stages. So you are halfway there. The next step is to ensure the film is doing its best for you. To be able to use the Zone System effectively, it is necessary to get to know how your film reacts to your exposure and to your processing techniques. That means making a few tests. We can of course expect some things to remain constant. For example, Ilford HP5 and ID11 are the same when used by any fan of the combination. The variation is in how you use them: your technique and timings; your camera and processing methods.

Right: the zone system is ideal for a variety of subjects, but is perhaps best known for its application to scenics. With it you can monitor and precisely place tonal values in all parts of the scale. More important, it is a means of helping you to visualise the finished print before you have even pressed the shutter-release button.

The camera is a mechanical device and is not necessarily perfect. Shutter speeds, remember, may have all the familiar numbers but this is no guarantee that they operate at the speed indicated. They may be a fraction slower or faster, and as such variations are not constant from camera to camera, there will be basic exposure 'differences'. Then there is your meter to take into consideration. It may not give readings as accurate as those used by the manufacturers when fixing emulsion speeds. True, meters have a zero-adjustment screw, but readings can nevertheless vary markedly from meter to meter.

All this is not a disaster for the individual photographer provided the 'faults' are consistent. Once you become used to the idiosyncrasies of your equipment, you adjust your exposure technique accordingly. Similar variations occur with processing technique. The basic developer may be the same, but the way it is handled may make a great difference. As explained earlier, a more frequent or more vigorous agitation increases the rate of development, for example, and the subsequent denser negatives may lead you to underexpose, to compensate. Whatever may be happening to your film, adjusting things so that you get a negative you like the look of is not precise enough for the Zone System. And that, despite all the tests and explanations given so far, is exactly what you have been doing. It is possible that you have hit upon the right combination; but this must be checked.

The first test establishes the exposure performance and gives you your own individual emulsion speed. You may feel that you already had this when you worked out the best medium grey (pages 71–74). However, that can be best described as coarse tuning, to get more or less on station. Now you are going to bring the station in properly, with full high-fidelity. You are going to fine-tune your film. The test takes advantage of the fact that wide variations in processing have little effect on the lower densities of the negative, and thus the basic emulsion speed alters little in spite of variations in the development procedure.

First we need to find Zone I. Set up your target as before (page 72) and once again write down a shooting plan. The idea is to shoot progressively at Zone V (direct metered value), Zone 0 (lens cap on), and Zone I (five steps down from Zone V), over a limited range of emulsion speeds. These begin at half the indicated emulsion speed, and continue up to four times the speed, in one-third stop jumps. You can do this by altering the film speed indicator and taking another reading each time, instead of adjusting the aperture only. As before, keep your shutter speed setting constant. Use your aperture to make the changes in exposure, and the curtains over the window to adjust the light level, as you did previously.

When the film has been developed in the normal way, look for the frame showing a slight difference between Zone 0 and Zone I. Then, starting two emulsion exposure indices slower than the one you have chosen, position the frames in your enlarger so you can see roughly half the Zone 0 frame and half the Zone I frame projected onto the baseboard. Make a test strip as you did for finding the minimum exposure needed to achieve a maximum black (page 73). When you have a suitable strip with greys through to black at Zone 0, move on to the next faster film speed setting (Zone 0/Zone I frames) and make another test strip. Keep going in the same way until you have five or six developed test strips with the relevant film speeds marked on the back of each one. When they are dry, study them carefully. Look at the Zone 0 side of each strip and follow the steps down until maximum black is reached: that is the first point where it becomes really black and can go no blacker. Check across to the Zone I side; if you can see a slight difference in tone under a good light, you are there. If you cannot, keep looking at the other strips until you find one; then all you need to do is to turn it over and read off your individual film speed.

For finding an accurate Zone I, and thus the correct film exposure index, make a test strip of the Zone 0 and Zone I frames together. Where maximum black occurs on the Zone 0 side, check 'next door'. If you see the barest hint of tonality above maximum black, you have found your correct exposure index.

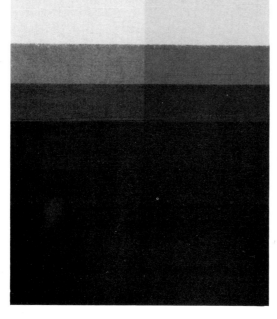

values on your tone ruler. All you get then is an indication as to the starting point for further tests.

Set up your target again and shoot from Zone 0 through to Zone IX at your new film speed, inserting an additional Zone 0 in between Zone VIII and IX. Cut this section of film out of the camera in the dark, and repeat the process. Do this until you have five film strips for development experimentation. Process the first one at the new

Development time
Exposure problems having been solved, you must now make sure you are developing the films correctly. Make a print of the Zone V frame accompanying your selected Zone 0/Zone I combination, using the maximum-black technique. Compare the result with your grey card. Should they match, then you are already processing for the correct time. If your test is darker than the grey card, you are overdeveloping for the new film speed; if it is lighter, you are underdeveloping.

Even though your new exposure index may make the film speed lower than you are used to, to ignore it is to court disaster. It is the lower values that are affected most. If you use your film at a higher speed than your equipment and techniques demand, you are effectively underexposing. Separation between the lower tones then practically disappears. Aim at getting your personal film speed right, and you can be sure of good detail in the low tones.

Let us suppose, as is likely, that the development is not correct. You can find out the size of the error if you compare the Zone V picture with your tone ruler. It may match with Zone IV, for example. You know then that you are overdeveloping to the equivalent of one stop. Note the processing time. Likewise, if your Zone V matches the tone on your ruler which is equivalent to Zone VI, you are underdeveloping by one stop. In all probability, you will find that the result falls between two

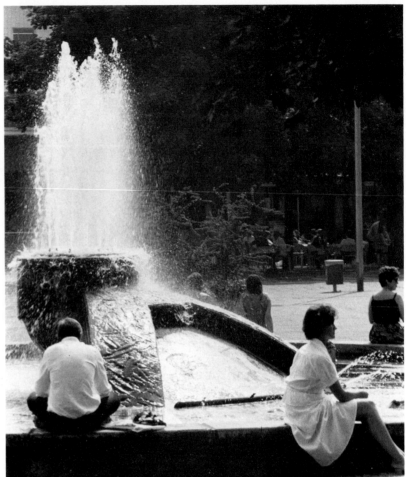

development time, assessed from your evaluation with the tone ruler. Assume a one-stop shift is effected by 30 per cent change in development time. It is a rough-and-ready guide, but useful as a starting point. So, if your Zone V matches Zone VI on the ruler, process your first film section for 30 per cent less time than before. If it is half way between Zones V and VI, try a 15–20 per cent reduction. This should then give you somewhere around a correct development time. Should the

Zone V have been correct, go ahead and process the first film strip for the same time again.

Now take two of the other film sections and process one for 30 per cent less than your new standard developing time, and one for 30 per cent more. Among these, you should find one which is correctly developed for the new personal film speed. When the films are dry, print test strips as before, this time using the half-and-half frame

Above: it is the higher values that suffer when developing times are wrong. Too long a time raises them too high; too short makes them too low. The lower values are affected hardly at all.

Far left: to find the correct developing time for your film at the new exposure index, test-strip the Zone0/Zone VIII frames of films that have been given different times. Where you see maximum black on the Zone 0 side, you should be able to discern a slight tonality below paper-base white on the Zone VIII frame. Then you know that development is correct.

Effect of development manipulation on the tone scale. Top: underdevelopment. Centre: normal development. Bottom: overdevelopment.

technique on Zone 0 and Zone VIII. On the dry strips find the maximum-black point on the Zone 0 side. Where development is correct, you will see, opposite, on the Zone VIII side, a slight greying. That is the first step into tonality from pure paper-base white. Should the Zone VIII value be too light, that film has received too much development, and has become blocked up. If it is too dark, it has been undervalued by insufficient development.

Now, it is possible that none of the three film strips has shown a correct developing time. You must then assess which way you are erring: whether towards underdevelopment or overdevelopment. Having done so, you now correct it by a 30 per cent shift on one of your other film strips. When you eventually find the right one, you will end up with strips which represent processing times of 30 per cent and 60 per cent either side of your new standard time, i.e. five strips in all.

Zone shifting

With these film sections now developed for the various times, you can now see what happens to your film under all conditions. Contact-print your zoned film-strips and cut out the frames of each one to make new tone rulers. As you compare them you can see how the tonal values alter as the developing time is extended or reduced. Keep them with you at all times, to tell you how to cope with difficult situations. It might seem that all this checking is too time-consuming, and that the Zone System is too cumbersome for use, particularly for action photography or at any time when speed is of the essence. As always there are short cuts; in any event, you do not always need all the information before you shoot. Where you are in a hurry, zone quickly and expose for the shadows. This gives you the basic exposure, putting Zones 0, I, II and III in their correct places. Later, when time is not so pressing, simply run a check on the highlights. When you find where they are placed in relation to

the shadows, you can develop accordingly. There you have it: a sophisticated version of 'exposing for the shadows and developing for the highlights'. Do not be put off the Zone System by all the tests and experiments, and the verbiage required to explain them. On paper it may seem to be complicated, but things are always more difficult to describe than to do. Once you have got over the tests and mastered the knack of zoning, you will find it an extremely valuable tool for precision control in the production of fine, sparkling prints.

Development and grain
Grain size is usually associated with emulsion speed: in general, the faster the emulsion, the larger is the grain. However, grain can to a large extent be brought under the control of the photographer. As you probably know, a grain is not an individual silver halide particle; this is a tiny crystal visible only under a microscope. The process of development causes these microcrystals to turn into filaments of silver which clump or coalesce, the amount of clumping determining the visibility of the grain, or graininess as it is called.

Graininess depends on a number of variables. Apart from emulsion speed, graininess depends to some extent on the choice of paper surface and grade. Glossy surfaces and contrasty grades emphasise grain. The enlarger illumination system also plays a part: a condenser system emphasises grain, whereas a diffuser system tends to suppress it. Exposure also plays a large part. Overexposure is one of the main causes of excessive graininess. Overdevelopment is another; it is during development that the clumping of the silver filaments occurs. Grain size depends on the type of developer and the extent of development. If you accidentally overdevelop a film, at least you have the consolation that you can use a softer grade of paper and minimise the effects. As you might expect, curtailed development gives lower grain size. The use of a highly dilute developing solution can also reduce graininess under some circumstances, e.g. where the developer formula

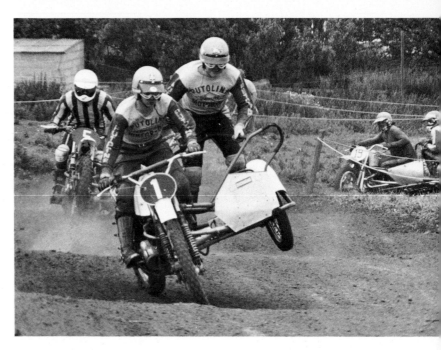

contains substances which exert a solvent effect on the silver halides.

Categories of developer and film
Developers can be arranged broadly into three groups. High-energy developers are vigorous in action, and reduce the maximum number of halide particles to silver, thus giving maximum emulsion speed. With any given emulsion they produce the largest grain size. The second category is low-energy (or semi-fine-grain) developers. These are designed to minimise grain size while preserving adequate emulsion speed. In the third category are the ultra-fine-grain or solvent developers. These contain a substance which is a solvent of silver halides, so that the developing grains do not have a chance to spread; these developers give the smallest grain size of all, at the expense of a marked reduction in effective emulsion speed. There is a sub-category, some members of which belong in the high-energy and others in the low-energy group. These are the high-acutance (high-definition)

The zone system can be applied even to subjects where you must shoot fast and accurately. Since you now know how to ensure shadow detail, and how to control the highlights through development, simply meter a shadow and place it on a suitable zone. Take your pictures and later, when time permits, take a reading of the highlights. When you know where they are placed, you can develop accordingly.

developers, which give full emulsion speed, but restrain the contrast and at the same time boost image definition. Many of these bear the prefix 'Acu-'. The table on page 116 is not intended to be comprehensive. It should be taken only as a general guide, as in some cases the boundaries between the categories are not clear.

Like developers, films fall into three broad categories. The first is the slow film with a thin

emulsion, ultra-fine grain and high resolution. Typical of this category are Ilford Pan F, Kodak Panatomic-X and Efke Adox KB14. These are most useful where a wealth of detail and the highest possible definition are required, as in close-ups, copying or still-life, where the low emulsion speed is unimportant. The second category is the medium-speed film such as Ilford FP4 or Kodak Plus-X, which is suitable for most general work. Such films have fairly fine grain, with less contrast and more exposure latitude than the slower emulsions. The third category is the maximum-speed film such as Ilford HP5 or Kodak Tri-X, which are invaluable for action photography or low-light work. There are also the new dye-image emulsions, which you can process to almost any speed you like with very little graininess.

The type of photography you do most of tends to determine the type of film you buy; consequently, when you make a foray into a different field of subject matter, your favourite film may not be the optimum one. The answer is to process the film for the subject, rather than sticking to a standard procedure and getting an inferior result. If you need to increase resolution and minimise grain, and your film is HP5, for example, simply use an ultra-fine-grain developer. For this type of work the reduction in emulsion speed is not particularly important. If, on the other hand, you normally use a slow, thin-emulsion film, you can boost its speed for low-light work by using a high-energy developer, preferably one of the high-definition type which do not give excessive contrast. There will be some increase in grain size, but as the slower films are inherently fine-grain this will not be serious.

Let us, for the purposes of illustration, look at one or two combinations. Suppose that your film for general-purpose work is FP4, and your developer ID11. This low-energy developer is adequate for most subjects, giving good resolution and tone gradation. If you need finer grain you can switch to, say, Perceptol. Your emulsion speed will be reduced

Forced development, giant enlargements, and hard paper ensure highly visible grain for special effects.

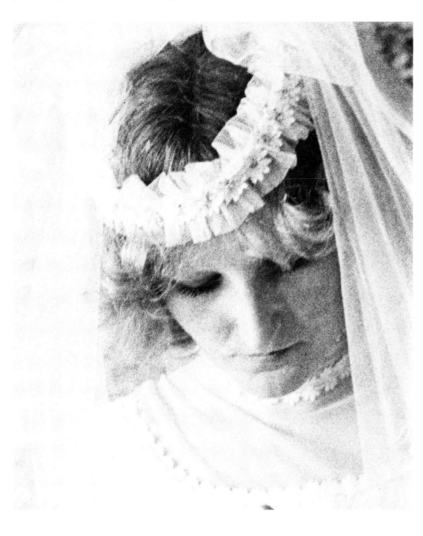

by one stop, but the grain size will be small enough to be virtually indistinguishable from that achieved by a slow, thin-emulsion film. Thus by changing to another, more appropriate developer, you have in effect a slow, fine-grain film. If you are taking high-speed action photographs or working in low light, you can process your FP4 in a speed-boosting developer such as Kodak D82. This will give you an effective speed not very much less than that of HP5 (and a corresponding increase in graininess).

This raises an interesting point. If you process a fast film in a fine-grain developer its effective speed will be much the same as the effective speed of a medium-speed film processed in a high-energy developer. Which is the better to use? As your experiments will no doubt show, there is little to choose as far as grain size is concerned. However, fast films have an inherent contrast that is lower than that of medium-speed films, and the use of a fine-grain developer will render it lower still. You may thus find you have to use a more contrasty grade of paper to print on, and this will accentuate the graininess. On the other hand, the contrastier medium-speed film with a high-energy developer will probably print best on a softer grade of paper, which minimises the grainy appearance. So, all in all, a better result will usually be obtained by the use of a slower film and a more energetic developer. This also applies to a comparison between medium-speed and slow films treated in a similar manner to that described above.

Grain for effect

All this is fine if you want to minimise graininess. But you may want to introduce grain into a picture for effect, to get the special, gritty image so appropriate to certain industrial scenes. For this type of work even the most energetic of the developers listed above may not be enough. You need to resort to extreme techniques. The first priority is a very fast film with its inherent coarse grain. Kodak 2475 or Royal-X meets the requirements. Deliberately overexpose by one stop. For processing, pick a print developer such as

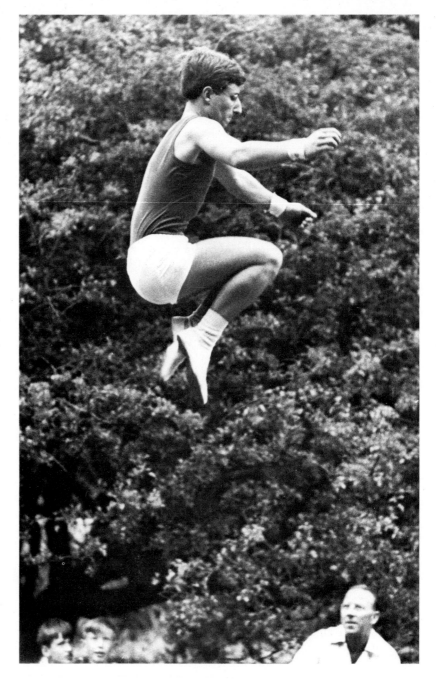

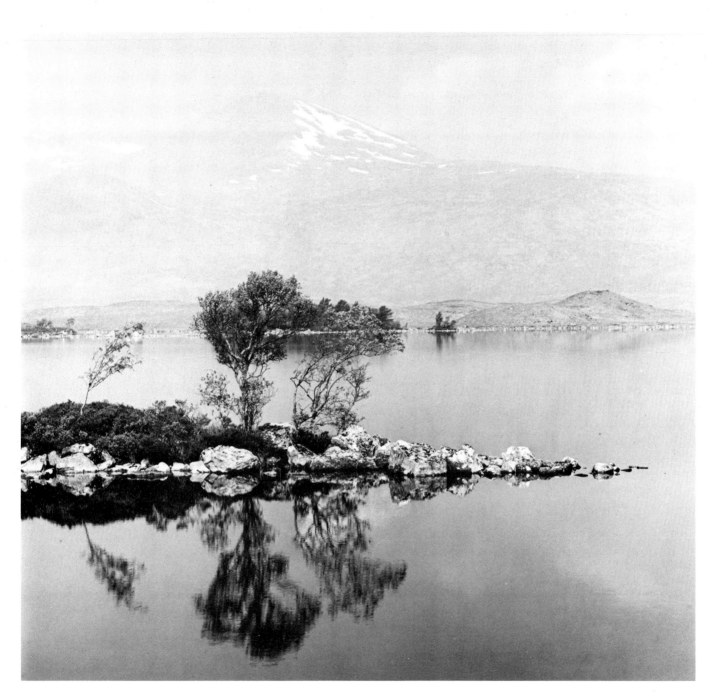

High-energy developers

Baumann Acufine	Effective speed increase of one stop but surprisingly fine grain. High-definition type, with outstanding edge sharpness and excellent resolving power.
Baumann Diafine	Effective speed increase of two stops with good grain for type. Resolution high.
Ilford Microphen	Rather less high energy and less grain. Full emulsion speed.
Kodak D82	For achieving maximum density with minimum exposure.
M&B Promicrol	Rather less high energy; good grain. Wide range of tones, especially under poor lighting conditions.
Tetenal Neofin Red	High-definition developer combining maximum emulsion speed with exceptionally fine grain for the type.
Paterson Acuspeed	Speed-pushing properties increase grain, but tonal gradation relatively mild.

Low-energy developers

Agfa Rodinal	Semi-fine-grain with good gradation and sharpness.
Kodak D76/Ilford ID11	General-purpose developer combining fine grain with excellent gradation; some loss in emulsion speed.
Ilford ID11 Plus	Somewhat finer grain than ID11. Very clean-working.
Edwal FG7	General-purpose developer providing a long continuous tone scale.
Ethol Blue	High-definition developer with good shadow detail and fine grain.
Tetenal Ultrafin	General-purpose developer giving fine grain even with extended development. Good tone separation and shadows.
Barfen HD	High-definition developer with fine grain and a compensation effect.
Paterson Acuspecial	High-definition developer with fine grain and very marked separation of tones.
Paterson Aculux	Good tonal quality and gradation with fine grain. A slight compression of tonal values.
Kodak HC110	Clean working with very fine grain. Tonal separation and gradation good, rendering maximum definition.

Ultra-fine-grain developers

Agfa Atomal	Good gradation and contrast.
Baumann Acu 1	Maximum acutance combined with very fine grain and full emulsion speed.
Edwal Minicol II	Exceptionally fine grain, long tonal range and maximum acutance.
Ethol UFG	Minimal grain with good sharpness, normal contrast and extreme latitude.
Ethol Tec	Compensating developer for maximum shadow detail and acutance combined with exceptionally fine grain.
Ilford Perceptol	Extra-fine grain with some loss of emulsion speed. High resolution and sharpness.
Kodak Microdol-X	Clean-working, low grain and high resolution; some loss of emulsion speed.
Tetenal Neofin Blue	High-definition developer giving a wide range of tones and moderate contrast.
Tetenal Leicanol	Very fine-grain compensating developer for wide range of tones and maximum shadow detail.
Beseler Ultrafin FD1 & 2	High-definition compensating developer; fine grain and exceptional sharpness.
Beseler Ultrafin FD5	Fine grain and a long tonal scale.

Pages 114, 115: the difference between fast films (in this case uprated Tri-X) and slow, thin emulsions (here Pan F, taken with a medium-format camera) is evident in these two pictures. *Raymond Lea; C. F. Lim.*

Right: a medium-speed 35 mm film and standard developer can produce extraordinarily sharp and vivid results when handled carefully. *Graham Whistler.*

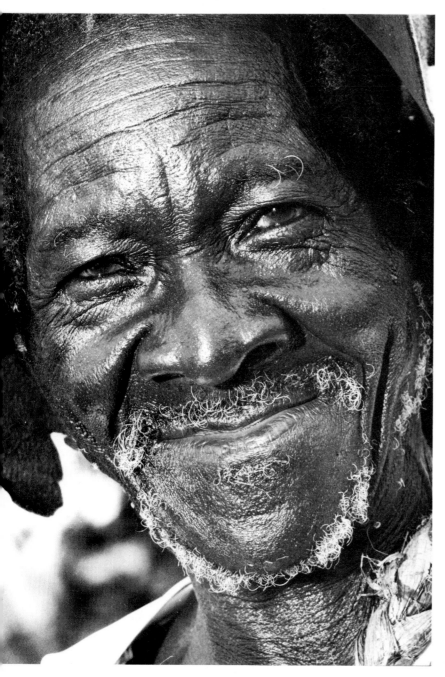

Kodak D163 or a maximum-energy negative developer such as D19 or DX80. Give double the normal development time, and the result will be grains so big you can see them on a contact print. Now enlarge onto Grade 5 paper, and the grain will be big, gritty, crisp and atmospheric.

Although by using the methods described above you can decrease or increase graininess, for most of the time you will no doubt prefer to work with a middle-of-the-road, semi-fine-grain developer. At one time everybody seemed to use Kodak D76 (or Ilford ID11, which is the same formula), but there has recently been a trend towards the slower films used with high-definition developers such as Paterson Aculux and Acutol. These have the advantage of being in liquid rather than powder form; they are used once only, at considerable dilution, and then discarded. They give full emulsion speed, in some cases enhancing it, and the images they produce are full of detail and with sharp, crisp edges. They are in general not fine-grain developers, but this does not matter as the slower films have inherently fine grain. The contrast is well controlled, and shadow and highlight detail well handled. This makes negatives processed in these developers easy to print. There is one major disadvantage. Because these developers manage the extremes so well, the mid-values tend to be compressed. This may not be troublesome in negatives containing a full range of tones, but in low-contrast subjects where almost all the tones are mid-tones they may not give the necessary separation. Nevertheless they work well for most subjects.

Speed-pushing

The finest results are only possible with a film when it is exposed at its correct emulsion speed; this raises doubts about the entire principle of speed-pushing. Of course, shooting at a higher emulsion speed than the rated one is simply underexposing. The shadow areas are going to suffer, so why risk an inferior image? The answer is expediency. If underexposure followed by an

A medium-speed film, with its exposure index halved and developed in an ultra-fine-grain developer such as Ilford Perceptol or Kodak Microdol-X, produces virtually grain-free images. In pictures with large areas of even tone, the smoothness and sharp detail give the impression that it was shot on a slow, thin emulsion. *Ben Storm.*

Overexposure and overdevelopment are great grain makers. Unfortunately they also tend to destroy fine detail, and are best saved for special occasions.

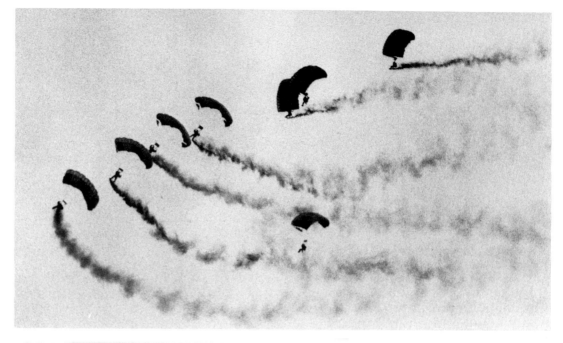

The advantage of the new breed of high-definition developers is that they are liquid, are used on the 'one-shot' principle, and are therefore highly convenient. However, they are not true fine-grain developers. They tend to compact the mid-tones, and in pictures that rely heavily on these there may not be as much separation as you would like.

energetic development is the only way of getting an image, then it must be done. Indeed, in some cases, this 'inferior' image helps to express the mood, particularly in action shots or at night. In any case, under these conditions we rarely get a clear view of the subject with our unaided eye. To see it in full detail, frozen, is at odds with reality. The imperfect impression possible with speed-pushing helps the idea of realism along.

The next question to ask is: under what conditions is it necessary to speed-push? There are three broad areas under which such an action is necessary. The first, obviously, is when the light is low. Under controlled conditions it is possible to increase the intensity of the light, of course, but when you are working in the field it is difficult. To use flash may destroy the natural atmosphere you are seeking. You must use ambient light, together with its attendant contrast problems.

Secondly, you can speed-push for special effects. Gross underexposure loses all shadow detail and some detail in the mid-tones as well. The result is extreme low key, with heavy shadow everywhere, relieved only by the highlights here and there. There is mystery about the image: dark, heavy, moody.

Thirdly, under controlled or natural conditions, you will frequently find yourself in a situation where a very fast shutter speed is desirable, coupled with a small aperture for maximum depth of field. To achieve this at the rated emulsion speed you would require exceptionally bright light; so, instead, you turn to speed-pushing. Underexposure by two or three stops may do the trick and give you the results you require. This third application should not be thought of as a licence for using a speed-pushed film for all your natural-light work. The temptation is great, especially if you find a combination (exposure + development) which produces adequate images. When you are in a position to photograph anything, at any time, you have immense freedom. But to speed-push all the time is too much of a good thing.

It is preferable to see speed-pushing as an emergency measure. Use it only when the subject and conditions dictate. Naturally, you cannot change conditions in the middle of a film and turn a film with its first half shot at ISO 400/27° into one with its second half exposed at ISO 1600/33°. Unless you cut the film in two and process the two parts separately, you will spoil half your film; if you do cut, you may be sure you will cut through the middle of the most important picture. So you develop for one half, and the other half suffers. Moreover, you should not push the speed any more than necessary. The less pushing you have to do, the better will be the final image. You should develop the habit of giving the optimum exposure for the subject matter and lighting conditions.

Begin by taking a reading at your individual emulsion speed. Check what your exposure meter tells you. If the shutter and aperture are suitable for what you have in mind, and it is surprising how often this happens, you will have good quality

Right: at times it pays to emphasise the dark values to create a mood of mystery. Exposure is based entirely on the highlights, and the shadows are underexposed. Make sure the tones in which you are interested have sufficient exposure, and let the rest take care of itself.

Below: speed-pushing is not reserved only for low-light shots. In cases like this, where you need a high shutter speed, adequate depth of field and a long lens, you may have to resort to underexposure and overdevelopment. However, push the film speed only as far as is necessary to achieve the effect you want.

images to print. Should the exposure time be too long and/or the aperture too large, adjust the exposure downwards a stop at a time, until you meet your requirements. For example, if the fastest shutter speed you can get at ISO 400/27° is $\frac{1}{60}$ s, but the subject is moving too rapidly for it, cut the exposure time, say to $\frac{1}{125}$ s to underexpose by one stop. On this occasion, that is all that is required. There is no need to go to higher shutter speeds; better to have an image which is only slightly pushed, and therefore only slightly deficient in quality. On another occasion, you might have to go to three stops underexposure; but in both cases you have sought to provide the optimum exposure for the conditions prevailing. Having done so you apply the best processing technique within the limitations, to make sure you get the best image possible from the emulsion.

Before leaving film speed, it would be as well to sort out the best type of film for speed-pushing. Not every film is equally suitable, though most will respond. The slower films, for instance, do not lend themselves well to the technique. The problem is contrast; slow films build up contrast at an alarming rate during extended processing, often taking the negative beyond the ability to print on the softer paper grades. In any event, why push a slow film when all you need to do is use a medium-speed film? Faster films, however, with their wide latitude, respond well to speed-pushing techniques. They are able to cope with the contrast problems as they are basically low in contrast to begin with. They are also able to show detail in the shadow areas where one would expect to lose it. Being versatile and resilient, and at the limit of the speed range, they are perhaps the best for speed-pushing techniques. Nevertheless, do not feel that the slower emulsions are totally unsuitable for speed-pushing techniques. With some care it is possible to get quite good images. In any case, remember that the best you can expect from any pushed film is only an impression.

121

Processing for increased speed

Controlled underexposure must be complemented by controlled extra development. To begin with, as we learned earlier, you must build some density into all parts of the negative. Secondly, you need to wring every last bit of detail out of each tone. There are two ways of achieving this in the processing: by prolonging the development, or by using a maximum-energy developer. In the first case, you use your regular developer, and simply keep the film in for more time. In the second, you use a special developer which has a built-in characteristic of increasing the film speed. To use the film at its regular speed and then process it in one of these developers would give you excessively dense and grainy negatives.

In either case, two undesirable things happen. First, negative contrast increases. Since a high-energy developer is in effect giving extra development, it builds up contrast too; this can be just as high as with extra development. Secondly, grain becomes obtrusive, as clumping is aggravated by the treatment. However, grain is accepted as a regular feature of speed-pushed pictures.

Recognising the problems and setbacks inherent in speed-pushing, and appreciating that it must be done with great care, it is now necessary to decide on which technique would best suit the image you have in mind. There are a number at your disposal, all of which have stood the test of time, and produce excellent results. They can be applied to many of the different low-light conditions you will experience. These can be as varied as those found under standard daylight.

The dull flat light of heavy overcast weather is one case. Contrast is low, which is fortunate, considering the contrast-increasing development that is to follow exposure. The soft lighting of dawn or dusk can also be put into this category. On the other hand there is the full contrast of a sunny day when you need to use a long-focus lens to capture some sporting activity. The shutter speed

has to be fast enough to avoid the danger of camera shake and freeze subject movement. True, the long-focus lens and atmospheric haze may lower contrast, but this may not be enough to keep the contrast manageable when increased by extra development. Finally, there are the ultra-high contrasts of night scenes. The scene consists almost entirely of bright lights and deep shadows, and there are hardly any mid-tones present. Such conditions tax the most versatile emulsions; to

Left: when deliberately seeking grain, choose a very fast film. Kodak Royal-X Pan was used here, exposed at half its normal rating and developed in a high-energy developer for 80 per cent extra time. This ensured a visible grain pattern, which is exaggerated by the backlighting. Finally, the picture was printed on a contrasty grade of paper for maximum graininess.

Right: although you can expect a visible grain structure on fast films that have been speed-pushed and processed in vigorous developers, it is possible to subdue it by printing on a softer paper grade. As vigorous development increases contrast, such a printing action is usually desirable. While the grain can be seen in the original of this shot, it is by no means offensive and at a reasonable viewing distance cannot be discerned.

increase the problem by forced development is foolish.

Techniques
All of this strongly indicates that in order to counteract the various conditions you need a variety of processing techniques. To use the same speed-pushing technique for all is inappropriate. Again, contrast-metering (the two-zone system) and tone rulers come to the rescue. If you make

tone rulers using the techniques described below, and apply them to the metering techniques, then you have an answer to almost any problem that can be thrown at you.

Low contrast Increase the developing time of your standard developer, about 30 per cent for each stop underexposure. Your previous experiments will stand you in good stead for this technique. Alternatively, use a speed-increasing developer. There are plenty around, including Baumann Acufine, Baumann Acu 1, Baumann Diafine, Ilford Microphen, Paterson Acuspeed, Kodak DK50, M&B Promicrol, Perfection Super Speed, Perfection High Speed/Fine Grain and Ethol Blue.

Normal contrast Whatever you do, it is important to try to retain the basic seven-stop contrast ratio for direct printing on a normal paper grade. Instead of just increasing the speed of your standard developer, try diluting it more as well. This has a compensation effect, controlling the contrast as well as increasing the speed. Whatever extra development you intended must be added to the new (extended) time necessary for the higher dilution. Some developers like D76, ID11 and Paterson Aculux give higher dilution factors. Alternatively, use a standard developer with an appropriate additive, for an increased development time. Foremost among additives is Minmax Factor 8. It is added to the developer in amounts determined by the extra development required. It prevents build-up of fog, grain and contrast. A variation is Maxitol Boost from Polysales. This is used after development and before fixation. It boosts film speed without the usual build-up of contrast and grain.

Finally, you can develop the film as normal and later intensify the underexposed, thin negative. Uranium intensifier is a two-part solution, available in powder form from photographic dealers. Mix it with one part of acetic acid, and immerse the negative until the desired density is reached. The heavy yellow stain is then removed with three or

Night-time is full of contrast, bright lights and deep shadows, with hardly any mid-tones at all. Where they do exist, it is important to try to maintain them and give them their proper value, while keeping the extreme contrast under control. Compensation development is ideal for this purpose. By diluting your developer much more than usual and extending the processing time accordingly, you can produce a suitable range of tones in your negatives, with virtually no grain, at speeds ranging up to three stops faster than your exposure index.

four changes of distilled water. This intensifier builds up density without appreciably affecting contrast. There is a slight increase in grain.

High contrast First, there is the very high dilution technique outlined earlier. Dilute as much as 1:5. The effect on contrast is magical! Agitate during the first two minutes of processing, and then leave the film alone for the remainder of the time, generally about five times the standard processing time. Grain is minimal, and the technique will handle negatives shot at different speeds, from ISO 200/24° (on an ISO 400/27° emulsion) to ISO 6400/39°. What is more, though listed in the high-contrast category, this method can be used under practically any conditions, as it seems to have a built-in contrast control which, more often than not, turns out negatives which will print on Grade 2 paper. Secondly, you can develop to finality in your standard developer, at normal dilution. This technique uses fog to lower contrast. When you give gross overdevelopment to a normally-exposed

film, the fog builds up, eventually becoming severe. Here, however, it helps to cut down the excessive contrast increase. Develop for four hours, with agitation continuous for 30 s followed by 10 s every minute for five minutes, then 10 s every five minutes for the first half hour. Then leave the film alone for the remainder of the time.

Where the contrast is extreme, try *latensification*. This means that you intensify the latent image between exposure and development, by exposing it to a weak light source. This has the effect of raising the threshold speed of the film. The light must not be too strong or it will fog the emulsion. A dark green safe-light with a 15-watt bulb, at a distance of about 3 metres, is sufficient. The room should be blacked out completely, of course, because this process takes about one hour. An alternative method is to expose the film to the light of an electronic flash, from a distance of at least 5 metres and with several thicknesses of handkerchief over it. You will need to experiment with latensification,

Baumann's Diafine has the effect of actually sharpening the image. It increases the film speed by two stops and tends to give a grainy image. However, even in bright conditions it somehow seems to control contrast and keep it within manageable proportions for use with normal paper grades.

as it is not easy to get it all right. Too much exposure and you get fog; too little and there is little or no effect. After latensification, simply process the film as normal. An alternative method involves exposing the film to a grey card *before* exposure to the subject. This requires a multiple-exposure facility, however.

Tests
With every method, you should experiment to find out what happens to the tonal values when you push the speed. Such findings help you to pre-visualise the effect at the shooting stage. Make your tone rulers as before, using the speed-increasing methods described here, and study the relationships of the resultant tones. Always start by obtaining a good Zone V at whatever speed you propose to work at, and then use the exposure/developing time to make your new tone rulers. Then you will find out how much damage speed-pushing does to the lower and, higher values. Once you have all this information at your finger tips, the problems of low light and short exposures will disappear.

Test strips and contact sheets

All the previous emphasis on obtaining exact tonal representations on the negative is now about to bear fruit. At first it may have sounded unnecessary. After all, one of the great advantages of the black-and-white medium is its flexibility. To a certain extent this extends to printing too. In theory, it is quite possible to put a Zone V on a print when it does not exist on the negative, simply by increasing or decreasing the exposure. However, as we learned earlier, there can be problems, and the production of a first-class print is not always possible. Moreover, we are in search of optimum negatives, optimum processing techniques, and optimum prints. And the optimum print is a Fine Print.

The struggle to attain a negative which represents the original values is a worthwhile one. For if we get *this* right, the print quality is secure, at least technically. In this respect the negative is the most important contribution to the photographic end-product. You cannot take too much care over its production. Apart from some brief digressions into photographic vision, this book has almost entirely been devoted to exploring aspects of exposure and development as the primary factor in producing a good negative. The concern has been to get it right in the first place, so that the printing stage is almost a fait accompli. You simply do what the negative tells you. Now, this sounds as though printing is more or less mechanical; of course, it is no such thing. Even though everything you need technically is on the negative, there is still room for final creative touches. You will want to print darker on occasion because the mood of the picture demands darker, heavier tones than the original scene possessed. There will be times when you will want to boost or diminish contrast for aesthetic reasons. Alternatively, you will want to add a touch of extra exposure to a small area here, or hold it back there.

Valerie Bissland (left), *Michael Dobson* (above)

The precision negative permits all this. It is not an end in itself, like a transparency (although even that can be altered and creatively personalised by manipulation in a slide copier). A precision negative is well-exposed, with a full range of tones containing detail in all but Zone I and below, and Zone IX and above. Starting with such a negative gives you room for manoeuvre. With skilled technique you can move in almost any direction to create the effect you desire.

Paper grades

The selection of a printing paper is a question requiring your earnest attention. Too often, all the effort is put into choosing a film and developer. Printing papers somehow seem to be no trouble. They just do the job; indeed, they all seem to do the same job. But there is more to it than that.

Certainly they all make pictures, but there the similarity ends. Apart from the various surface textures available, some papers produce good, rich blacks with clean, white highlights, and others seem to produce, in comparison, muddy shadows and dingy highlights. However, as with film, the choice must be a personal one. If you are fond of muddy shadows, you are entitled to follow your preference. But if you prefer rich blacks and clean whites you have a further choice between papers which produce cool blue-blacks, neutral blacks, warm blacks, or even brown blacks.

The issue of black-and-white printing, which seemed to be so clear-cut, is now beginning to appear complex. There is much more to selecting a paper than just using the one stocked by your local dealer. Play the field. Seek out the paper which holds the greatest appeal for you. There may be only a vague feeling that the quality of one of them is more 'you' than any of the others, but trust your judgement. In short, as you are in the business of producing the optimum print, get the paper which you feel will do your negative justice. You have struggled this far; struggle a little more. It will be worth all you give.

The test for personal evaluation of the tones is simplicity itself. Place a sheet of paper on the enlarging easel with the negative holder empty and the lens aperture fully open. Cover half the sheet with a piece of opaque card, expose for 30 seconds, and develop normally. The exposed side will give you the best black the paper is capable of, and permit you to compare it directly with the best (unexposed) white. To get a valid answer to your search, you should use papers of the same grade in this test. However, this is where you will encounter

The lot of the monochrome photographer is to produce a negative which represents, in shades of grey, the tonal values of the original subject. These have to be placed on the film in such a way that, after correct development, they can be printed on a normal paper grade in such a way as to give full value to all the tones present.

a problem. Grade numbers from different manufacturers often do not match. For instance, Agfa-Gevaert's Grade 2 resembles Kodak's Grade 3 in contrast, and Grade 2 Ilfospeed is slightly higher in contrast than 'normal' Multigrade. Your black/white tests will be of real value only if you compare papers of the same contrast, which are not necessarily the same nominal grade. To help you find the nearest grades, the table on page 144 compares some of the popular papers.

When testing one paper against another be scrupulously fair, and use the same type of surface throughout. Do not, for instance, try to compare a Kodak Matt with an Ilford Glossy. Choose, if you like, your favourite surface; but make sure there are similar surfaces on all the papers before you run your tests (it is quite possible that there are not). Glossy surfaces may not be your meat, but just about every manufacturer of paper has one. A glossy surface does have distinct advantages. To begin with, no other paper is able to record detail quite as well. It is also capable of depicting the widest range of values (paper contrast permitting) with highly subtle tonal nuances.

RC versus fibre-based papers

Despite the cries of the critics, it *is* possible to directly compare fibre-based papers with the resin-coated (RC) type. True, there is no gloss like an RC gloss, but you are really looking at blacks and whites, are you not? The arguments about the relative merits of the two papers still run hot. Many workers assert that RC papers are not as good as fibre-based papers; the quality of the image, they say, is inferior and they fade too quickly.

Let us have a look at the two arguments and see if they make sense. Quality tends, to a large extent, to be subjective. However, it can be broken down into two important factors: the depth of the blacks, and the brightness of the whites.

To take glossy surfaces, which give blacker blacks than any other paper surface, the place to begin is

the claim made by the company which manufacture your favourite paper as to the maximum density (black) possible. Kodak, for instance, say their paper has a maximum density potential of 1.75. Yet exposure tests through a step tablet reveal that maximum density for Kodabromide (fibre) paper is 1.80, and for Kodabrome (RC) is 1.90. Ilford claim that their maximum density is 2.05, whereas tests with a step tablet show that Ilfobrom (fibre) is 2.13, and Ilfospeed (RC) is 2.08. In all cases, the densities of the blacks produced by these papers are higher than claimed by the manufacturers. Where Kodak is concerned, their RC paper produces deeper blacks than their fibre-based type. Ilford's fibre does produce a denser black than their RC, but the difference is only 0.05, a difference which is barely visible.

Now, as to the whites at the other end of the scale: we are, in effect, looking at highlights which record virtually nothing; that is, they show as paper-base white. Therefore everything depends on the reflectance of the paper itself. RC papers have a substrate incorporated into the paper which actually increases reflectance and produces brighter whites. This enhances the contrast. However, this substrate is at its most effective only when the print is processed correctly. When the wet-time is extended beyond the optimum, these brightener layers begin to dissolve.

The optimum wet-time for an RC paper is 8 minutes. This comprises 2 minutes development, 10 seconds stop bath, 2 minutes fixation, 4 minutes wash. The first three steps are not difficult to adhere to, but when it comes to the wash old habits die hard. Fibre-based papers need a long wash; the fixer must be thoroughly washed out of them. RC is coated on a plastic base and the chemical solutions do not penetrate it. Therefore you need only to wash the emulsion. With fibre-based papers the tendency is to print the lot, throwing them into a constant flow of running water to wash. They build up here until the end of the session, and you then set about drying them. On the other hand, RC

These two photographs were both shot on medium-speed film (FP4), but clearly require different papers. The backlit scene needs a 'hard' paper to maximise its gleam and sparkle, whereas the subtle tone gradation of the shot taken in mist calls for a 'soft' grade of paper. *Raymond Lea; Ben Storm.*

papers must come out of the wash after 4 minutes; any longer, and the brightness and contrast begin to deteriorate. Moreover, the dissolution of the brightener may leave the print with a mottled appearance showing clearly in the lighter and middle tones. Fibre-based papers have a substrate consisting chiefly of barium sulphate, which is almost totally insoluble in water. Soluble brighteners are not used. Indeed, their use is out of the question, because of the long washing time. The base reflectance is therefore lower.

Having said all that, the differences are minimal, showing up only under the most exacting tests under controlled conditions. Compare a well-exposed and processed RC print with a fibre-based one produced under the same conditions and, apart from the feel and look of the paper itself, you may be hard-pressed to tell the difference. Image for image, the quality in terms of blacks and whites (and all tones in between), and the difference between them, is to all intents and purposes identical. As for permanence, RC papers appear to compare favourably with fibre-based papers. (Naturally, we are talking about papers which have been given correct processing, with optimum washing time.) Both will fade under direct sunlight, although fibre-base papers tend to fare better and last a little longer under these circumstances. In addition, RC papers have to be kept away from excessive heat (they can melt!), radiation (the TV) and all solvents which will affect plastics.

To sum up, the advantages RC papers have over fibre-based ones are the short processing time and short washing time, no dryer is required, the paper dries flat and stays stiff throughout, and it has a high-gloss finish (best for fine detail). Fibre-base papers score over RC in that they are less expensive, there is a greater choice of base colour and surface, they are easier to batch-process, the surface is less susceptible to damage, spotting is easier and mounting is simple too.

Naturally, fibre-base addicts pounce on the latter list to support their case. However, while the first three items may be critical factors in your choice, the remaining snags can be overcome. The fast throughput, for example, encourages you to avoid attempting batch-processing. With the necessity for only a four-minute wash you can work almost as fast churning prints through one at a time. As a direct result you are less likely to damage the emulsion or to get uneven development. Spotting is comparatively easy if you use the special oil-based medium available for RC prints, and mounting is achieved using adhesives produced for the purpose and used cold. As for the expense, the extra you pay for the paper is easily recouped in saved electricity in terms of drying and of darkroom time.

None of this will affect the debate, of course; both sides will continue to have their adherents. Recently the supporters of fibre-base have been given a boost by Ilford's introduction of high-quality fibre-based paper produced with exhibitions in mind. Called

As with the negative, you want to see your favourite paper giving full separation and detail (where possible) in the lower values, while holding on to the higher ones. Different papers give different blacks: some warm, some neutral, some cool. Find and select one that suits you and gives them the richness you feel they deserve. *Manuel Torre.*

'Galerie', it gives a very full range of tones and excellent gradation. Moreover, with the general photographic world going RC-mad, this paper appears to have been introduced against the general trend. Nevertheless, the fact that it has appeared at all indicates strongly that the demand for fibre-based papers is far from dead.

Variable-contrast papers

Both Kodak and Ilford manufacture variable-contrast papers. Kodak's Polycontrast is available either in fibre-based or RC types, Ilford's Multigrade in RC only. The great advantage variable-contrast papers have over graded stock is that you have to buy only one paper. With the aid of filters this paper can become any grade you wish, within the limits of the system. With traditional papers you must stock all the grades you are likely to use, because a contrast problem might eventually turn up. Using variable-contrast paper, to obtain a particular grade you introduce into the light beam one of a set of filters specially produced for the

The advantage of Multigrade is readily seen in this set of pictures. By the use of filters and an adjusted exposure time it is possible to produce normal, soft or hard images all on one stock of paper. Each print has received the same exposure time (subject to filter factors), so the lower values have remained unchanged as to density. But note the effect on the lighter tones.

paper you are using. There are two layers of emulsion coated on the base, one of low contrast and the other of high contrast; they are colour-sensitised to different parts of the spectrum. By choosing an appropriate intensity of colour filtering you can alter the balance of sensitivity between the two emulsions and obtain any contrast grade you wish.

The beauty of the system is that you are not stuck with grades in arbitrary steps. A negative does not have to be printed, say, on an equivalent of Grade 2; if it requires just a touch more contrast, but not enough to warrant a Grade 3, you simply make a part of the exposure through one filter, and the remainder through another, and thus produce an intermediate contrast. What is more, whereas on graded stock you can dodge and burn-in only with opaque masks, and you are limited to lightening and darkening local areas, on variable-contrast papers it is possible to dodge with filters. These hold back light in the same way as any other filter. Thus a small piece of filter held over an area which needs to be lightened will stop some of the light reaching that part. At the same time it can be made to increase or decrease the contrast over that area. The same applies to filters used for burning-in.

Printing practice
The point of all this is to find a paper which does justice to your negatives. You need to express the full range of tones from rich, deep blacks to paper-base white. Throughout the range the print must show good gradation, separating close tone-values and revealing detail clearly. The greatest difficulty in print-making is that it is not always easy to recognise what is good. When prints are made purely by subjective judgments, the quality can fluctuate wildly. Therefore, as in every other stage, there is a need to remove any variables. Many of these occur during printing. Some, of course, arise in processing, and these will be dealt with later. However, the biggest problem lies in getting the printing exposure right. It is here essentially that the print is made. Variations in

processing produce only slight variations in quality. As for the actual time of exposure, no doubt you can control this without too much difficulty. A darkroom clock, a digital timer, even the second-hand of a watch, will take care of it. Where the subjectivity lies is in deciding how much exposure time to give.

The method of finding the correct exposure has already been touched on more than once. Find the minimum exposure necessary to achieve maximum black in a clear part of the negative, and nothing is left to chance. Maximum black is completely objective. Consider the normal practice; a test strip is the usual starting point. A piece of enlarging paper is laid in the masking frame in such a way that it can be exposed to the widest range of tones possible. Then it is exposed in progressively increasing time steps. This is done with a piece of card, laid on the paper and covering all but one-sixth. It is exposed for two seconds. The process is repeated after the card is slid back to

A print that is representative of your previsualised image needs a standard and precise darkroom technique. All stages must be controlled and timed meticulously, from exposure through developing and fixing to drying. Get them all right and you can be assured of values as you exposed them, in the correct relationship. *D. Doble.*

reveal another sixth (as well as the first), and so on. The result is a piece of paper with exposed strips of 2, 4, 6, 8, 10, and 12 seconds, covering a full range of tones. After fixation, the progressively-darkened bands are studied in room light. The band which looks right is chosen as the correct exposure, and a further piece of paper is exposed for the time suggested by the strip. The alternative is to use some kind of enlarging exposure meter. But then the decision as to what looks right is a subjective one. What makes *you* happy may be much too dark or too light for your neighbour.

The key to be objective approach lies in Zone 0, i.e. clear film. When it is printed, it appears as the blackest black. If we can locate our Zone 0s, and make them print as maximum black, all the other tones should fall into their proper places, provided we have exposed the negative properly. The trick is to get the black right. If it does not receive sufficient exposure it will be grey, not black. Overexpose it, and it will certainly be black, because maximum black can get no blacker; but all the other tones are affected too, as they will all be shifted to darker values. Thus the test to find the minimum exposure to achieve a maximum black is crucial. Only this test is made into a test strip. The same procedure as for the standard test strip is used; but this time you read only the black. The point where it reaches a black that gets no blacker is your correct exposure for *all the tones* in that negative. Should there be no large areas of Zone 0 in the negative, you can resort to the same techniques as before, and use the

rebate. But this, again, presupposes that you have exposed the negative at your own individualised film speed. If not, you will quickly appreciate how far your exposures are out.

The contact sheet
The beauty of the 'minimum exposure for maximum black' method is that it can be applied just as readily to contact sheets. Using the film rebate as before, make your test strip and, after processing, find the point where maximum black is first reached. Then print your contact sheet. If you use the type of contact frame which holds the film by the edges, you must make your test strip with your film laid on the paper so that the rebate can be clearly seen in a frame window. This still permits you to close the frame tightly to keep the film flat. Note the height of the enlarger head, lens aperture used, and the correct exposure time, so you can use the same set-up to make further contact sheets without having to produce more test strips. But identical provisos apply to those mentioned earlier. If you change the film or developer, it is prudent to make another test strip.

Checking exposure
A contact sheet is a positive record and an index of your negatives. With one of these you can both interpret your negatives and find one when you need it. However when correctly exposed and processed, it can be the means of discovering a great deal about your photography. To begin with, there is the question of your own personal film

exposure index. Only when you have that right can you effectively use the maximum-black technique in printing. This information can be gathered using the minimum of film, by reading the contact prints of a simple exposure test. This applies to you only if you have not undertaken the tests outlined on pages 107–112.

Set up a subject containing a wide range of tones, including maximum black. It should be under a light of constant intensity, as if the intensity varies the results will not be valid. Meter the subject carefully, and expose as precisely as you can; then bracket. Repeat the exposure in half-stop steps up to two or three stops in the direction of the required correction.

Which is the required direction? If your previous contact sheets made to the 'minimum exposure for maximum black' method show the majority of tones as being too light, you must reduce the exposure. You have been consistently giving too much. Close the aperture down in half-stop steps. Should your previous contacts show underexposure, you must open the aperture in half-stop steps to give more density to your negatives. Make a contact sheet of your exposures and then study the dry print to see which of the steps gives the correct density. Where several prints are so similar in tone that a decision is difficult, make a full-sized print of each, again employing the 'minimum exposure for maximum black' technique. Study the shadow details; the print which gives the best, with a complete and correct range of tones above it, is the negative of the correct exposure. When you have found it, translate the exposure information into film speed. If your best print was from an exposure one stop above the metered setting, for instance, this indicates that your film should be shot in future at an exposure index of half the rated speed.

It would be silly to toss aside this new-found information in order to retain the marked film

speed on your meter. The truth is inescapable: you simply have not been exposing your pictures correctly. You have been over- or, more likely, underexposing them, in which case you have not been getting as good highlights or shadows as you could and the overall reproduction of the images will not have been correct. The most likely culprit is the meter itself, and rather than having an expensive recalibration it is much simpler (and cheaper) to simply amend your film speed.

After making the adjustments to your film speed, your negatives may still turn out either too dense or not dense enough. This means the development time has become incorrect. Try a modification of 10 per cent either way with the next film. If this is not enough, cut or extend by another 10 per cent, and keep doing this until the negative density is right. This sounds a bit hit-or-miss, but the tests (if you follow them through properly) will render you the best and most printable negatives you have ever had. However, it does not in any way replace the tests for the preparations necessary to use the Zone System correctly. Even if you do not use the Zone System, discovering your own personal film exposure index and developing time by finding a proper Zone 0/I and Zone 0/VIII is the precision way of turning out first-class negatives.

Negative information and film speed are only two of the items of data which contact sheets can provide. As long as you have basic exposure and development correct in both negatives and prints, you can use them to give you all kinds of information about other materials and about your equipment. For example, you can use the methods outlined above for discovering the true exposure index of your film and processing time when using speed-pushing techniques. You cannot expect as good a range of tonal values, particularly at the lower end of the scale. However, proper exposure and development (even at a higher rating) should provide you with an overall density which comes close to matching that of your regular negatives.

A contact sheet is more than a record of your negatives. When exposed correctly it tells you whether you are giving the correct film exposure; it also gives you an impression of whether or not a negative is worth working on. You can use it to make initial compositions, and to select the best negative of a number of similar shots.

Testing shutter speeds

When making tone rulers, emphasis was placed on adjusting apertures only, because you cannot guarantee that your shutter will give you precise step values. The fact that you now use the 'minimum exposure and maximum black' technique in printing does not alter this, but it can be employed as a means of calibrating your shutter speeds.

Set up the Zone V targeting system as outlined on page 108. Then photograph it at a straight Zone V exposure. Let us say this is $f/5.6$ at $1/125$ s. For your next exposure, again shoot at $1/125$ s but close down one-half stop. Then repeat with the aperture opened up one-half stop from $f/5.6$. If you used $1/125$ s for all your previous tests, you know that the first shot will produce a proper Zone V. Now open the aperture to $f/4$ and alter the shutter speed to $1/250$ s, ostensibly to give the same exposure. Photograph your target. Shoot again with the aperture closed down one-half stop, and again

The correct exposure in the enlarger is the only way of getting a correct valued print. If you get that wrong, nothing you can do during development will correct it satisfactorily. The key lies in the blacks. If you underexpose, they are too light. If you overexpose, they are black, but all the other tones are too dark; there is also a lack of separation among the lower tones. Get the blacks right first, and let the higher values take care of themselves.

opened up one-half stop from the established aperture. Repeat this procedure using all your stops and as many shutter speeds as you can. The faster ones from $\frac{1}{15}$ s up are the ones you need to check, because as the speed increases so the inaccuracy problems are aggravated. As in the other tests, keep a written record. It helps you to avoid mistakes and it gives you a ready-made chart for checking your results against later.

Process the film and contact-print it, using the maximum-black method. What you now have is a series of frames all hovering around Zone V. Compare them directly with your 18 per cent reflectance grey card to find the true shutter speed on each occasion. Sometimes it will be more or less right, sometimes it may be considerably out. Where discrepancies occur, work out on which setting the Zone V was achieved. Let us say that this was $\frac{1}{500}$ s, Zone V was produced at the stop + one-half stop, i.e. half-way between $f/2.8$ and $f/2$ on our plan. You know now that $\frac{1}{500}$ s on your camera is underexposing by one-half stop. So to render values correctly at that speed you must always give extra exposure to the same amount. Indeed, to ensure that your camera is the precision instrument it is supposed to be, you could run tests on all shutter speeds at all apertures. Given a key density, which you have already established during earlier tests, you can relate test shots to it to see where each shutter speed/aperture combination stands. This method is by no means a replacement for proper shutter testing, but it is a practical means of finding

out for yourself just how accurate your camera shutter is.

Testing filter factors

The filter factor is engraved on the filter ring, but it can vary from camera to camera, and under different lighting conditions. Set up a subject with a full range of tones and colours under a light of constant intensity, and photograph it on every film type you regularly use under both daylight and tungsten illumination. Start by exposing for the manufacturer's factor and then bracket up to a stop either side in half-stop steps. Test all your filters in this way and then study the contact frames for the correct density as you did for shutter speeds. Where these occur, you have the right filter factor. Do not skip this test if you are a TTL meter user. The meter need not necessarily adjust automatically when a filter is placed in front of the lens, because it is unlikely to respond exactly like the film to light of every colour.

Testing flashgun guide numbers

Simply make exposures of either a suitable subject or, preferably, a target for producing Zone V. Start with the guide number indicated, then bracket in half-stops up to two stops either way. Test the flash in a variety of conditions, e.g. large and small rooms, indoors and outdoors, so that you are covered for all future eventualities. Always allow five seconds *after* the 'ready' indicator comes on before shooting. This is necessary to allow the flash to reach full power.

The guide number is given by the manufacturer of the flashgun for certain specified conditions. These are usually an average room with light-coloured walls. The guide number is based on the total light intensity reaching the subject, both directly and reflected from the walls and ceiling. If the room is larger than normal, or if the walls are dark, the light intensity may be lowered sufficiently to demand an extra stop exposure. Light intensity is also reduced considerably out of doors, reflective surfaces usually being far away or non-existent. In

Use the contact sheet to check on your filter factors. Expose a variety of subjects through various filters under different lighting conditions. If you bracket your exposures, you can identify those frames that have the correct density and represent the true filter factor.

addition, if you use a wide-angle lens the illumination from the flash falls off towards the edges, and this can make a marked difference to the exposure overall.

Test close-up flash as well. If you use a flash on an extension lead held away from the camera, this too will affect the guide number. In this case it is also important to remember that it is the distance of the flash from the subject, not the camera, that counts.

Testing marked *f*-numbers
Light transmission at a given *f*-number can vary from one lens to another. It can also vary, with some lenses, depending on whether you have moved up or down to the stop in use, because of backlash. TTL meters generally take this into account, but for the precision photography with which we are dealing it is worthwhile finding out whether this is indeed occurring. The method is by bracketing as described above; for each lens you should carry out two tests, one bracketing upwards from a smaller stop, the other bracketing downwards from a larger one.

Cleanliness, sharpness and contrast
To return to the test strip, there is much more to look for in the results than the maximum black achieved by the minimum exposure. Three of the more important items are cleanliness, sharpness and contrast.

Testing your flash guide number is also simplified with a contact sheet and the 'minimum exposure for maximum black' principle. When apertures are bracketed, it is possible through density checks to see whether the calculations suggested by the gun are correct.

Flash can be tricky, especially with close-ups. Use the contact sheet to ensure subjects reveal full detail. The shot below required the use of flash, close-up rings and a long lens. Each had to be checked first to make sure the subject would be correctly exposed.

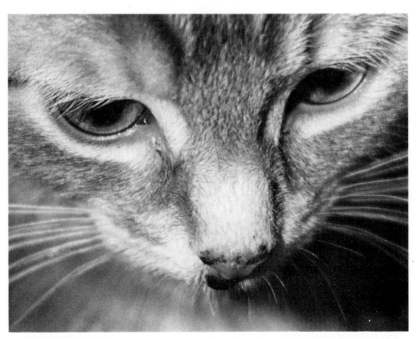

In a test strip the exposure bands should cover as many tones as possible. This often means test stripping diagonally. Look for more than correct exposure. Note the cleanness of the negative, the sharpness of the image, and its contrast. All these can be dealt with before you make the test print.

Cleanliness In the darkroom cleanliness is vital. Ensure the room is as dust-free as possible. The number one priority, however, is to keep dust and dirt off the negative. Although you should clean it carefully but thoroughly before you begin, it is possible that some obstinate dust will still remain. This is not easy to see in the projected image, and your test strip enables you to spot any offending marks.

A strict negative cleaning routine should be observed. Work from the most gentle to the more aggressive (within reason!). Begin with non-touch techniques. Try to blow off the dust first. Don't use your breath, which carries moisture and grease. Use one of the blowers made for the purpose; better still, use a pressure-can blower. Both of these can be obtained from photographic suppliers. Dust is often held in position by static electrical charges, and negative brushes, which are often combined

with blowers, may actually makes matters worse. The cure for this is to use an anti-static pistol designed for removing dust from gramophone records, and sold by hi-fi dealers under the name of 'Zerostat'. When this is pointed at the negative and the trigger pressed and released once, the air surrounding the negative is ionised, the static charge leaks away, and the dust simply falls off.

Scratches are another matter. If they show up white on the test strip they are on the back of the negative. Diffuse rather than condenser illumination reduces their effect considerably, but if they are bad the only way to deal with them is to provide a temporary filling with a liquid of the same refractive index as the base material (*indexing fluid*). If your enlarger has a glassless carrier, use medicinal-grade liquid paraffin. Pour a drop onto the scratched area and remove the surplus with a tissue. After printing, wipe the negative clean. If you use a glass negative holder, use xylol (xylene), or lighter fuel. In this case you should flood the negative, and ensure there are no air bubbles trapped. After removal from the negative holder the fluid will quickly evaporate, leaving the negative and holder clean. Xylol is highly flammable, so don't smoke or have any naked lights around while you are using it. Make sure your darkroom is well-ventilated, too. (Xylol is also an excellent cleaner for removing greasy marks and fingerprints from negatives and glass negative holders.) There are a number of proprietary film cleaners and anti-scratch dips on the market; these are of variable reliability. If you invest in one of them, experiment first with a valueless negative. The real answer is to prevent the scratches from getting there in the first place, by keeping the inside of your camera scrupulously clean, and filing your negatives in envelopes or a negative album.

All the above applies to scratches on the *back* of the negative, which appear white in the test strip. Black scratches mean that the damage is on the emulsion side, and no amount of cleaning or application of indexing fluid will get rid of them. There is nothing

White negative scratches can be 'removed' by using a drop of indexing fluid (medicinal liquid paraffin) or one of the proprietary scratch removers. The scratch is covered with a film of the same refractive index as the negative.

you can do except retouch the scratches or abandon the negative.

Sharpness Sharpness depends on five factors, namely accurate focusing, freedom from camera shake, cleanness of the optical system, use of optimum aperture, and focal length of lens. It goes without saying that no print will be sharp unless the enlarger is correctly focused. It is possible to focus the image by eye, especially if you use a watchmaker's eyeglass on the centre of the image and all four corners, but a better method is to use one of the enlarging magnifiers specially sold for the purpose. This allows you to focus on the grain itself; there is no better indication than that! Stand the magnifier on a piece of waste enlarging paper held in the masking frame, bringing the grains into focus at the equivalent level of the surface of the paper you are going to use for the print.

A problem related to enlarger focusing is what is popularly known as *popping*. Under the heat of the enlarger light source the negative may spring up from the plane on which you originally focused; it will then no longer be sharp. Your enlarger should have an adequate heat-absorbing filter between the lamp and the negative carrier; if there is nevertheless a tendency to pop, wait until this happens before focusing and exposing. Popping will not occur if you use a glass negative holder. Of course, all this will be wasted if the negative is unsharp in the first place. Make accurate focusing and a steady hand a habit, and you will get good, sharp pictures.

Shake is not confined to the camera exposure; it can occur during enlargement too. It is only too easy to jar the enlarger in the middle of an exposure, especially if the head is near the top of the column. Avoid touching anything but the on/off switch during exposure. Do not use the red filter to make the exposure. Moving it is likely to transmit vibration to the rest of the enlarger.

Sharpness is desirable in any negative, but it is of particular importance in images with intricate detail. Look for ways of improving sharpness all the way from shooting to enlarging.

Keep the optical system in the enlarger completely clean. If the condenser or lens has dust or fingerprints on it the sharpness may be impaired. The scattered light will introduce a fuzziness at shadow/highlight edges. The shadow areas, being brightest on the negative, will spill over into the highlight areas, reducing detail.

Although you should always buy the best enlarger lens you can afford, any enlarger lens, like any camera lens, has a range of apertures which produce the sharpest results. A critical examination of the grain image with your focusing magnifier will reveal what this range is; for a good-quality lens it is likely to be roughly between $f/5.6$ and $f/11$. If you work outside this range you may do less than justice to the negatives you have worked so hard to produce. The outermost zone of a lens does not in general produce an image that is as sharp as that produced by its central portion. Moreover, when a lens is used at full aperture there is a risk of degradation of the image tones through flare.

Closing right down raises a different problem: diffraction. When a light beam passes through a very small circular aperture it tends to spread; the amount of spread increases as the aperture decreases. As the aperture is closed down, contrast and definition are progressively lost from the fine detail in the image. As these two effects work in opposite directions, there will be an optimum range of apertures for any lens.

These effects are fairly small in a good enlarging lens, so do not worry too much if for some reason you need to work with the lens at maximum or minimum aperture. A simple further test you can carry out to find the optimum range of apertures with your enlarging lens is to sacrifice one of your old, useless negatives, and make a scratch from corner to corner across the emulsion. Make a print at each aperture, labelling the prints on the back, and after processing examine them with a magnifier to see which one shows the scratch the sharpest. Examine the scratch from end to end.

Surprisingly, the focal length of your enlarging lens can influence the sharpness of the image. It is customary to use a normal focal length lens in an enlarger, e.g. 50 mm for a 35 mm negative. However, a lens of equal quality with a focal length intended for the next larger format (e.g. 80 mm) gives better coverage, for improved sharpness at the edges, and gives a more uniform illumination over the picture area. True, such a lens will give a smaller image, but for most purposes this will be no great hardship. Where larger prints are required you can project onto the wall or floor.

Contrast Contrast is the final factor to examine on your test strip. Of course, every effort has been made to expose and develop so that the negative has a contrast suitable for printing on Grade 2 paper. However, that is not always possible to achieve. Unless you are using sheet films which you can process individually, it is often necessary to have several different contrasts on the same length of film. Where such negatives stray from the norm,

An example of the effect of selecting the right contrast for the image. The brightness ratio at the scene was 64:1, despite the appearance of extreme highlights and shadows in juxtaposition. Development to a higher CI was impossible because of the need to maintain correct contrast between the remainder of the tones; therefore contrast had to be controlled in printing. Note how on the normal paper grade (top) the highlights lack punch. They need to be extended to make them whiter, as the maximum black exposure has dragged them down somewhat. Therefore Grade 3 paper was used (bottom) and the contrast corrected.

zone range (contrast ratio)	A	B	C	D	E
				0	extra soft
10(1024:1)			0	½	
9(512:1)		0	1	1	soft
	1	1		1½	
8(256:1)	1½			NF	
7(128:1)	2/NF	2	2	2	special
	2½			2½	
			3	3	
6(64:1)	3	3		3½	normal
5(32:1)	3½		4	4	
	4	4		4½	hard
4(16:1)		5	5	5	extra hard
3(8:1)					

Paper grade chart. The brands included are: (A) Kodak Polycontrast (filters), (B) Kodak graded, (C) Ilfospeed, (D) Multigrade Mk II (filters), (E) Agfa-Gevaert.

therefore, different paper grades are required, and perhaps even some specialist printing techniques to rectify them. Having found the minimum exposure for achieving maximum black, then, you now simply check the highlights to see if they are where they should be. If they appear to be too dark, or grey, then the picture lacks contrast and requires a higher paper grade. Should they be too light and lacking detail, there is too much contrast and a softer grade of paper is required.

Which paper grade is required is another matter; in time experience will tell you. However, a fairly accurate approach is to relate the contrast ratio of the original scene to the paper. If you recorded your exposures, you will have all the necessary information to hand. Then you can apply it to the paper grade chart shown opposite. All you have to do is find the relevant brightness or zone range in the left-hand column, and then follow it across to the column which corresponds to the paper brand you are using. There you will see the recommended grade for normalising image contrast. It is important to realise that this conversion chart is merely an indication of comparative grades. It is not intended to be wholly accurate or definitive. Use it as a guide, and adjust papers and development as necessary to conform to your own personal techniques.

The important thing with contrast control is not to overdo it. It is easy to go too far and be satisfied with a print simply because it looks better than your first attempt. Instead, build up or soften the contrast in steps as small as feasible. The indication, remember, is in the higher values. Always start with maximum black first. Get that right, then work out what contrast adjustments need to be made. Then leave the black where it is (it has to remain a black) and vary the higher values by varying the paper grade. If you are using graded stock, you will have to make a full test strip for maximum black every time you try out a new paper grade. On variable-contrast paper, however, you can use the same basic calculation for each filter.

All you do is add the time for the new filter factor and then make a straight test print.

Factors affecting contrast

It is worth digressing at this point in order to examine various things which affect contrast in negatives and prints. For negatives there are the primary factors of subject brightness range and subsequent development, of course. But there are also other factors. To begin with, your camera lenses: some are inherently contrasty, others much less so. Long-focus lenses, for instance, when used at long distances, put a lot of atmosphere in between you and the subject and soften the image. Then there is the film itself; with normal processing, faster films produce softer images. In the darkroom, contrast is also affected by the enlarging lens, not in terms of focal length and paper-to-lens distance, but in the construction of the lens itself. Different makes and qualities have differing inherent contrasts. If you change from one to the other to accommodate a different negative size, you may well change the contrast too.

Then there is the enlarger illumination system. There are a variety of systems extant, basically of two types: condenser and diffuser. The former is used most commonly for black-and-white enlargement, while the latter may be specifically designed for colour. The illumination systems in most enlargers intended primarily for black-and-white work follow a similar pattern. The bulb is a slightly over-run 75- or 150-watt opal. The opalised surface helps to produce evenly distributed illumination. Below the bulb is a sturdy heat-absorbing glass. This traps the heat and prevents much of it from passing on down to the negative, enabling the latter to stay cool and thus remain flat. Of course, if the bulb is left on for extraordinarily long periods, excessive heat will reach the negative and cause it to pop out of focus. Beneath the heat-resistant glass is the condenser. This consists of two plano-convex lenses with their curved surfaces facing one another, or sometimes a single lens. They capture the light emitted by the

A condenser (top) focuses light into the enlarger lens; a diffuser (bottom) scatters it.

bulb and transmit it towards the negative as a converging beam, focused approximately in the plane of the lens. This system produces a concentrated and intense illumination. The optical image is full of detail, and seems to have better definition and higher contrast than the image produced by a diffuser system.

The Callier effect The reason for this lies in what is known as the *Callier effect*. Because of the focusing effect of the condenser, all the light in the transparent shadow regions of the negative passes directly through the enlarger lens. However, in the denser regions the silver grains scatter much of the incident light, so that it never reaches the lens at all. The result of this is considerably increased contrast. The effect is most marked in regions of comparatively low density, so that when printed on an appropriate grade of paper (i.e. about one grade softer than required for a diffuser system) the darker tones are more strongly separated than the lighter ones. The Callier effect also causes grain to

show up sharply, and emphasises any scratches or scuffs. For this reason, many condenser enlargers have an optional partial diffuser of ground glass which is placed between the lamp and the condenser, and somewhat lessens the effect without losing the advantage of increased clarity of image. For the same reason, almost all condenser enlargers use opal bulbs.

Colour negatives, and the new dye-image monochrome negatives, have an image consisting of dyes; because no silver grains remain (they have been removed in the bleach-fix part of the process) there is no scatter and thus no Callier effect. There is accordingly no point in using a condenser system, with its emphasis of scratches and other superficial marks. Colour enlargers, and some large-format black-and-white enlargers too, usually employ a low-voltage compact-filament tungsten-halogen source with its light aimed at a hollow diffusing reflector or 'integrating sphere' which illuminates the negative with uniform diffuse light.

Buying a colour head for your enlarger is not the only way of obtaining a diffused light. If you replace the condenser with two discs of ground glass separated by about 25 mm you will get uniform diffuse illumination. As explained earlier, you can get intermediate illumination with a single ground glass resting on top of the condenser; this will reduce contrast by about half a paper grade compared with full condenser illumination. This is useful where you have a negative with a contrast lying uncomfortably between two paper grades.

Another method used in diffuse-source enlargers, and particularly suited to large-format work, is what is known as cold-cathode illumination. The lamp is a grid-shaped fluorescent tube. Unlike domestic fluorescent lamps, which have a hot filament for a cathode in order to allow operation at mains voltage, this lamp is operated via a step-up transformer which permits the use of a cold cathode and avoids the necessity for a heat-absorbing filter. Cold-cathode heads

sometimes contain a lens, but its function is simply to even out the illumination; it is not a condenser.

Condenser or diffuser? At the outset of this look at illumination systems, it appeared as if some enlargers were more or less categorised as better for colour or for monochrome work. In fact, condenser enlargers can be used for colour work (they are generally fitted with a filter drawer for colour balancing) and colour heads can be used for monochrome work. So do not feel trapped if you have only one type and wish to extend your repertoire into another field of photography. Although you have decided to embark on an exploration of the merits of black-and-white, there is no need to buy a second enlarger. Use the one you have, and learn its idiosyncrasies. Once you have found the quality of negative that suits it best, you can tailor-make your negatives to produce optimum results with it.

Extremes of contrast

Accidents will happen, and from time to time you will be faced with the need to print an important negative that has a range of tones that is well outside the capabilities of even the softest paper. There are two possible courses open to you. First, you can try water-bath development. Immerse the paper in the developer and agitate until the barest hint of image appears. At once transfer the print to a dish of plain water and agitate it there until all action ceases. Return the print to the developer, and as soon as the image begins to strengthen transfer the print to the water bath again. Keep doing this until the image is fully formed. You are getting a compensation effect. The intermediate water bath dilutes the developer within the emulsion so that activity is quickly exhausted in the shadows but continues in the highlights, building up highlight detail but controlling the contrast. The number of water baths you give depends on your dexterity; the more the better.

Alternatively you can use a soft-working developer. Kodak's Selectrol Soft is one; other examples

include Tetenal Centrabrom, Agfa 105 and GAF 120 Soft Working Paper Developer. All of these reduce the contrast of the paper by about one grade. You can also increase contrast by choosing an appropriate developer. Tetenal Documal and Agfa 108, for example, increase the contrast of any given paper by about one contrast grade. A useful developer for contrast control is Barfen CD. By considerably diluting it you can soften an image; by using it more concentrated, you can increase the contrast. However, a word of caution. Before racing out to buy a cupboardful of chemicals, ask yourself whether the negative is really worth it, and, if so, whether dodging or burning-in might solve the problem. A close examination of your test strip will tell you.

A water bath during paper development lowers contrast. In the above shot the lighting contrast is enormous, and is further increased by the need to speed-push. To hold the contrast back, simply immerse the print in a water bath several times during development of the image; this acts like a compensation technique. Shadows are prevented from developing too far, while the highlights build up density and detail.

With some subjects you may want to keep the contrast high. In the photograph on the far left and the one on the right, for example, the mood would be spoilt by 'soft' printing. *Gerry Chudley; Michael Dobson.*

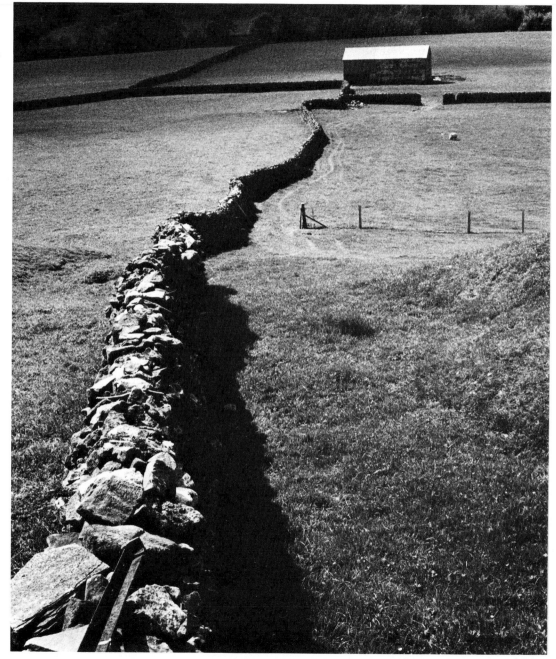

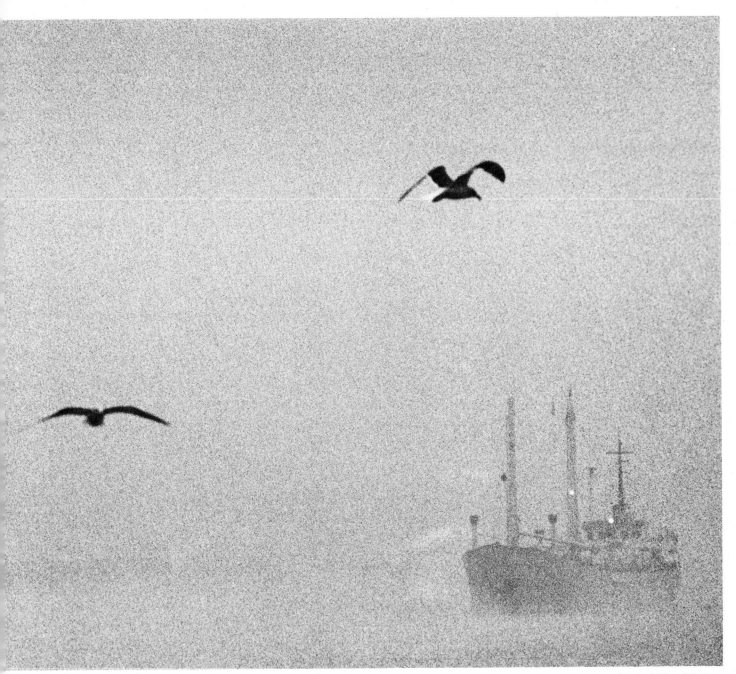

Frank Peeters

Making the final print

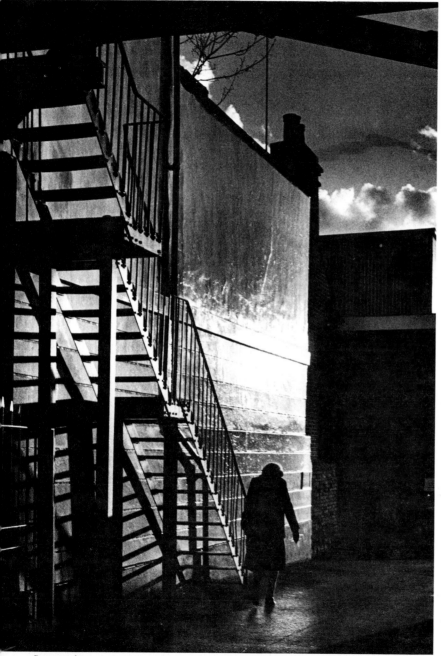

Raymond Lea

The next step towards your Fine Print is to make a test print. Even if you test-strip over the entire projected negative area, which is a common practice with professionals, you still need to see a straight print. Only then can you see the results of your adjustments and to decide whether any interpretative treatment is required, or indeed whether you are using the right negative.

Having got so far, it seems ridiculous to be questioning the quality of the negative. However, if you took more than one shot of the scene, perhaps bracketing, perhaps trying different filters, you may not in fact have selected the best. It is sometimes difficult to see all the detail in a contact print. This is only partly to do with size. A contact print and an enlargement are made in different ways.

When contact printing, neither the enlarger illumination system nor its lens plays any part in affecting the quality of the image. Also, in such a small size the image appears to be sharp even if it is not; given a reasonable negative, the gradation may appear superb. In an enlarger, a negative is influenced by the optics both above and below it; this can change the appearance of the image, as we discovered in the previous chapter. You need to examine an enlarged print before you can decide which of a bunch of similar images of one scene is the best.

Eliminating unknowns
Nowhere in the negative-positive process is it more important to remove variables than it is here. You made the test strip under strictly-controlled conditions, knowing precisely what was happening every step of the way. You must apply all that information exactly to the making of your test print. The exposure time, paper grade etc. are all easy enough, but things can go wrong during

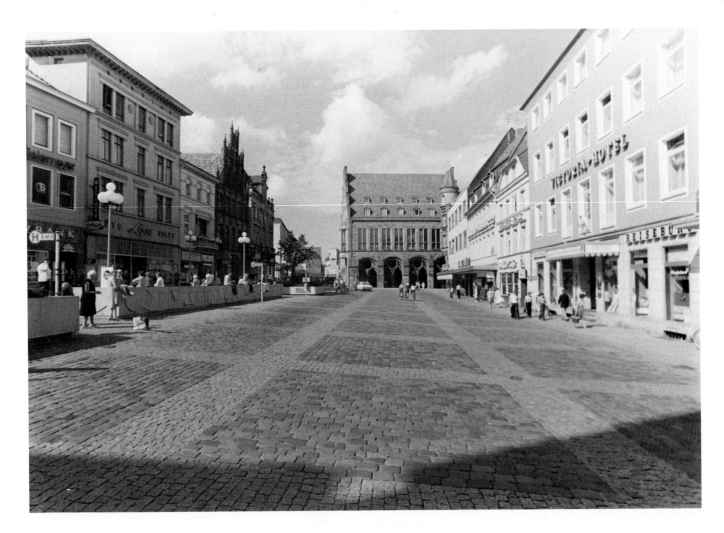

development. As with film processing the four variables are dilution, temperature, time and agitation. We will proceed on the assumption that you have diluted according to instructions. Unfortunately, as papers and paper developers are so flexible in processing, in many darkrooms time and temperature control is neglected. Many amateurs suffer from the 'that'll do' syndrome. They watch the image form and pull it from the developer when it looks right, or leave it in a bit longer, rubbing it with neat developer until they get the density they want.

That won't do. First, the development time *is* important, even with paper. You will not get the best results if it is either too short or too long. Too short and development leads to muddy blacks which have not had time to develop fully, and tend to be discoloured and uneven. The remainder of the tones are correspondingly light, with the higher

A test print is a necessary intermediate step between the test strip and the Fine Print. You need to see the entire image at the established exposure. Very often fine exposure adjustments are required, both overall and locally. For instance, the upper right-hand corner needs to be burned in. Overall, very slight printing down (5–10 per cent) is required. Also the negative has popped, resulting in lack of sharpness at the right-hand edge.

values beginning to lose their detail. In short, the print looks weak and washed-out. Too long a development time gives you deep blacks, but the other tones look very heavy, and grain may be obtrusive.

Secondly, temperature affects the processing time in paper development just as it does for films. Despite the fact that you can procure an image at quite a wide variety of temperatures, most developers do their best work at 20 °C. Maintaining the correct temperature can be difficult. The solutions are in open trays, and without some kind of temperature control they will rapidly cool down (at least in temperate climates). A water-bath helps. Set the trays in a larger tray and keep topping this up with water at the correct temperature. Alternatively use a thermostatically-controlled dish warmer. This is an electrically heated stage upon which you stand the trays; it can be adjusted to maintain the baths at a steady 20 °C.

One cheap and efficient method of temperature control is the use of a water bath with a fish-tank heater (similar heaters are sold for home wine- and beer-making). Choose one of 80–100 watts. With this, as with any other temperature control method, you need to check its calibration with a good thermometer. Mark the control clearly with the setting needed to maintain a developing-bath temperature of exactly 20 °C.

The final factor affecting development, and perhaps the most important, is agitation. This must be continuous and should begin *before* the paper is immersed in the bath. Rock the dish in an irregular manner; if the motion is too regular, standing waves will form in the solution and bars of extra local development will spoil the uniformity. As in all baths, the print should be removed from the solution shortly before the completion of the processing time, long enough to permit adequate draining. This gets rid of excess chemicals and helps to prevent contamination of the next bath.

Post-visualisation

Assuming that you have found the best interpretative negative and have sorted out time and temperature problems, the next step is to make the best print you can, and study it. To appreciate what you have in the test print, you must go back to the beginning, to the point where you committed the image to film, by making comparisons. Make them in three stages: (1) with the notes you made on your chart when you exposed your negatives; (2) with your tone ruler; (3) with the original scene, if possible. These three are linked closely together.

When the print is dry, compare the values present in the image with those recorded on your chart. Naturally, you will not have all of them noted down, but the few key ones will form the necessary reference points against which the remainder can be evaluated. For visual conception you will have to relate the print values to the tones on your tone ruler. It is all very well saying that a certain value seems to match a specific zone, but impressions can be deceiving. Compare the tones directly and make sure. The final and conclusive comparison is made, if possible, at the original scene. The conditions and lighting should be as far as possible the same as before, and a two-way check made, i.e. between the print and the tone ruler and between the print and the original. It could be, for instance, that you feel there is something missing in the image: it does not quite gel with your remembered pre-visualisation. The print/scene comparison will jog it into place.

The whole idea of post-visual reading is to make sure that you are on track, that you are following your first impressions and carefully-laid plans to completion. You need not feel completely bound by them, of course. Should further interpretative measures and ideas surface, go ahead and make what adjustments you feel you need. If you have a good negative and a good test print to begin with, you have a sound foundation upon which you can build any number of edifices. You can print down for mood, or up for a light, airy feeling.

Tone shifting

There may be areas of the image which are not dark enough or light enough for your preconceived impressions. Camera exposure adjustments, intended to ensure important subjects are reproduced at the correct value, may have shifted others in the scene too far to be acceptable. These need to be returned to the required density at the printing stage. Light tones can be darkened by 'burning-in'. This simply means holding back the light from the paper everywhere except the area which needs extra exposure. You can ascertain the required time from your test strip.

For burning-in, you need a card with a hole cut in it about half the size of the area to be burned in, and the same shape. After giving the basic exposure, insert the card about halfway between the enlarger lens and the baseboard. Keep it moving to avoid hard edges; when the area has received sufficient extra exposure switch off the enlarger lamp. The opposite applies to 'dodging'. This is the technique where an area requires lightening. Again you can get the appropriate exposure from your test strip. To do the dodging procedure you need a piece of card the same shape as the area to be dodged, and a little smaller, held by a wire attached to it. At the appropriate point in the exposure you introduce this piece of card, and, as with burning-in, you need to keep it moving to avoid hard edges. You may prefer to use a small piece of modelling clay, which can be moulded to any required shape; this makes an excellent dodging tool. Where a large area of the negative requires this kind of treatment it may be more appropriate to do the necessary shading with your hands. With this technique it will certainly take some practice before you are really proficient, but the ability is worth developing, as it will save a good deal of time over the years. You can lighten or darken whole foregrounds, skies, and so on. However, always try out your shading on the optical image *before* you insert the paper.

On a critical examination of the test print you may notice that the corners and edges are somewhat

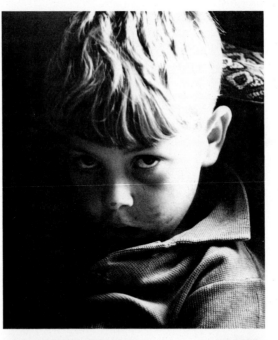

The effect of burning in a part of the image is clearly evident in the two pictures on the left. The first print is heavily underexposed on the side of the boy's head, obliterating detail completely. A localised extra exposure, using the methods described in the text, has given sufficient detail without losing the feeling of a strong Rembrandt style of lighting.

Dodging parts of the image that are too dark maintains local contrast without the loss of the entire picture. A small piece of card affixed to a wire, and held in he enlarger light beam above the printing paper for the required amount of time, holds back the light and prevents that part of the picture from being too heavily exposed. Note the difference in the tonal value of the hurdler's head in the first and second prints.

lighter than the centre of the print. This is the result of the fall-off in illumination that occurs from the centre to the edges with all enlarger lenses. For some reason it tends to be more apparent with condenser illumination systems. Using a lens of longer focal length than normal minimises this effect, as mentioned above. However, the effect may make it necessary for you to burn-in the edges and corner of the print to contain and strengthen the composition. Once again, your test strip will tell you how much extra exposure you need. This type of burning-in is most easily done by shading with your hands. At every stage, you must not let the apparently mechanical approach to printing inhibit you. Let your subjective feelings have the final word. Produce the values in the print which express what you feel needs saying about the subject.

The Fine Print

Technicalities having been sorted out, you are at last ready to make your Fine Print. However, before actually committing it to paper, go over the details and make sure the image will express the emotional and visual values of the scene which you previsualised. It could be that a simple thing such as a warm or cold tone will add that finishing touch. Perhaps the neutral blacks of your favourite paper may not be just the right thing in this case, and slightly warmer or cooler ones would be in order. You could perhaps re-examine your earlier paper tests, and find one to suit. As an alternative, try processing your favourite paper in a developer which produces, say a warmer tone. In this way you can exploit a known paper to the full and get the tonal appearance of the image you are seeking.

Paper developers can be grouped largely into three categories. There are subtle differences within each group, but only a very discerning eye indeed would be able to detect them. The groups, and some representative developers, are shown in the table overleaf. Some of these developers are borderline cases, and have been listed in the group into which they appear to fit most readily. The list simply indicates that you should take care over selecting a

developer which is going to give you the tones you want. Have one or two standing by for different results when the subject warrants it.

Now you have all the data you need, and are ready to make the final sprint: your Fine Print. Use all the skills, techniques and information you have discovered, and the loving care you have lavished along the pathway to this goal. This is the part which finally realises your reaction to and relationship with the original scene, via the media of exposure, development and printing. In this sense then, it is an extension of yourself: the print becomes a completely personal picture. It is an exciting moment, one for which you have planned and worked for right from the moment you first noticed the subject. Savour it and feel proud.

Spotting

Despite your meticulous cleanliness in the darkroom, it is possible that some stubborn dust slipped through your dragnet and shows as white spots on your print. You cannot leave these; they must be removed. The material for the job is spotting medium. This is a dye which is applied to the print to fill in those offending white spots to match the tone of the surrounding area. It is available as a liquid (water-based), as a solid block, or (usually oil-based) in tubes in different shades. The difference between water- and oil-based spotting medium is that the oil-based dyes are used with RC papers while the water-based medium is used with fibre-base papers. In either case, select the shade of grey from those available, or dilute the black medium to the shade nearest to the value in which the offending white spot lies. Select a 0 or 00 sable brush with a fine point.

First, you must match the spotting medium to the value of the tone. This takes practice. Always use a spare print to experiment on. Test the mix on it and see if it blends satisfactorily as regards tone. Start by transferring a small amount of the medium to a white plate or tile. If your medium is water-based, dampen the brush first in clean water. Then either

Paper developers

warm tones	neutral tones	cool tones
Agfa Brown Tone	Agfa Agetol	Kodak Dektol
GAF Brown-Black	Agfa Neutol	GAF Paper Dev. 103
GAF 113	Edwal Platinum	M&B Orbitol
GAF 135	Ethol LPD	PT Consol
M&B Embrol	GAF Amidol	PT Universal
Tetenal Centrabrom	Ilford ID20	Tetenal Eukabrom
	Kodak D163	
	M&B Suprol	
	Paterson Acuprint	

mix various shades of grey to achieve the right tone, or dilute with water. When the depth of colour appears to be right, dry the brush on a tissue, then moisten with a little of the medium, touch the tissue again and try the colour on your test print. Use a stippling action. Hold the brush almost vertical and touch the white spot with the tip only to make tiny spots which match the grain pattern of the print.

Judge the density of the result only when it is quite dry; spotting medium tends to dry a little darker than it is when wet. If you get it absolutely correct in its wet form, you may end up with dark spots all over the print when it is dry. Once you are satisfied, go ahead on your proper print. The odds are that you will have spots on various tones over the print. So if your medium is too dark or light for the tone you decided to work on first, you can always move to another that is lighter or darker. Indeed, some photographers prefer to mix the medium and then find a suitable tone, rather than the other way around.

If you are using a glossy surface you may find that the medium sits on the top of the print in a small globule instead of penetrating it. This can be avoided by spreading a thin film of soap over the plate or tile on which you mix the dye before transferring it. Alternatively, blend in a small touch

At last: the Fine Print.

of wetting agent when mixing. Both act upon the surface of the print, lowering the surface tension and allowing the dye to soak into the emulsion. You may also notice that the medium dries matt, and that this is very evident on the glossy surface. You can overcome this by mixing in some gum arabic; this can be achieved by running your brush along the gummed part of an envelope flap before mixing. The effect is a shinier spotting medium which is less obvious on glossy surfaces.

It pays to start spotting on the dark tones first. As you stipple away, the medium begins to thin out and gets lighter. Thus you can move over to a lighter tone and stipple there. Continue like this, moving to lighter and lighter tones until the medium on the brush is all used up, then reload the brush and start again. When all the blacks are done, lighten the medium and work on the greyer tones, again moving to lighter ones as the medium thins out. Start with the biggest spots. Spotting is an exercise in patience and big spots take a long time. In this way you will be fresh when you need to be, and prepared to spend time stippling over a large area. Later, when your patience has been sorely tested, you will be working on smaller spots which require very much less work to eliminate. Always work from the outside and move towards the centre of any spot. Again, you will take more care in the beginning and it is the edges that must be just right. Too much medium, or stippling on the tone which immediately surrounds it, will produce a dark ring, darker than the existing tone. Your spots will then be visible in another way.

When attacking scratches, use the same technique. Even though a scratch is long and thin, stipple. Treat the scratch as if it were a series of spots joined together. Work on the areas which run through darker tones first, and then move to the lighter ones, in the same way as described above.

Tackling black spots
You may have a black spot on a white area, which has to be removed. Alternatively, you may have

Sometimes dust and dirt seems to stick to the negative no matter what you do to remove it. Rather than risk ruining the film, print the picture, dust and all, and spot the finished print.

omitted to dodge an area which needed it and is therefore too dark. When you have the final print, it is too late to do anything about the exposure, short of making a fresh print, but you can bleach that offending value back a little.

A black spot on the print originates from a clear spot on the negative. Any number of things could have caused it: dust on the film during exposure, undissolved chemicals adhering to the film during processing, and so on. If you have a large negative to work with, it is better to do the retouching work there. But as most of us work in the smaller formats, it has to be effected on the print. Bleaches for this purpose are available as kits, or you can mix them yourself. The basic chemical is potassium ferricyanide (recently renamed 'potassium cyanoferrate'); when mixed with sodium thiosulphate ('hypo') it becomes 'Farmer's reducer'. The two chemicals are both dissolved in water at the rate of $100\,g$ to $1000\,ml$, but they should not be mixed until immediately before use, as the mixture does not keep. Take 1 part potassium ferricyanide solution to 10 parts hypo. This mixture is then diluted with a further 10 parts of water.

It is often best not to try to bleach the black spot to the same tone as the surrounding areas, but simply to make it white. Then you can retouch it with spotting medium to get it back to the right tone. There is no doubt that this method is the easiest to achieve since, as already indicated, bleaching is not the simplest thing in the world to control. But you might first like to try to bleach it to the right tone. If it goes too far, then let it bleach white, and retouch it in the normal way.

You need a good, sharp-pointed sable water-colour brush for the job. A No. 7, 8 or 9 will do fine. However, before using it, seal off the ferrule with a drop of nail varnish at the root of the hairs. This is to prevent the bleach getting up inside and causing stains which are hard to remove. The procedure is then as follows:

1 Wet the print in clean water containing a drop or two of wetting agent. This helps to reduce the surface tension and enables the bleach to get to work quickly.

2 Wipe off the surface of the print gently with a cotton swab, making sure you are not so rough as to damage the emulsion.

3 Apply a small amount of bleach to the offending area; leave for two to three seconds, then blot with a tissue or paper towel. Repeat if necessary.

4 From time to time, apply some fixer to the area and leave it to act for about 10 to 15 seconds.

5 If more bleaching is required, continue, checking its action with fixer on occasion as described above.

6 When the tone is the depth you require, wash the print off thoroughly to remove all the bleach, then re-fix. Wash the print and dry it.

There are workers who prefer to stay away from bleach entirely and use a retouching knife to remove black spots. A fine-pointed scalpel is the normal tool for this task, but a razor blade can be just as effective. The important thing is not to dig into the emulsion too deeply. Pare, rather than scrape, the emulsion away in light strokes, with the blade held at a shallow angle. All you need to remove is the top layer. This leaves you with a white spot for spotting with medium. With practice, it is possible to pare away the emulsion very thinly until the spot reaches the same tone as the surrounding area; should subsequent spotting be required, burnish the removed spot with a smooth, hard, rounded object to flatten the area so that the dye takes uniformly.

Lightening larger areas
Where a large area needs reducing or lightening, it is best to return to Farmer's reducer. This time apply it with a cottonwool swab in a random pattern, using the 'apply, blot, fix' technique

described for use on black spots. This time, though, you must watch the action very carefully, and halt it before it goes too far. If the bleaching has not gone far enough, you can always re-start it. Should you allow it to bleach too far, there is nothing you can do about it; you are going to have to make another print.

If you want to lighten the entire print, this is best done in a reducing bath. Immerse the print in a bath of Farmer's reducer, and agitate carefully as you would for development. Follow the same routine as described above, removing it from the bleach and washing off to check progress. It is fair to say that bleaching, like spotting, takes much practice. It is relatively easy to make the area or the whole image too light. Try the process out on some old prints at first until you get the hang of it. Once you have unlocked the secret, you will be able to use it with refinement and great effectiveness.

Naturally, the purists will say that if you have to do all that afterwork on a picture it is no longer a Fine Print, and you should go back to the darkroom to make a correct one. Be that as it may, many pictures can be saved simply by a little work and represent to the owner the end product of much careful and thoughtful labour, a product of which he can be justly proud.

Toning

When toning is mentioned, a brownish print is usually the first thing which comes to mind. That is because most toning is associated with the sepia process. In fact, toning covers a wider spectrum. Apart from there being a number of different colours to which you can tone your print, there is also a question of degree and purpose. Some photographers use light toning to alter the general colour of the blacks and to increase the brilliance of the whites, asserting that a few minutes in a toner makes the blacks richer and warmer and imbues the print with a unique brilliance and depth. Others use toning for effect: a delicate wedding picture sepia-toned for that Victorian look, a seascape

toned blue for its cool sparkle, and so on. Some even go in for partial toning, applying the solution to a particular area with a fine sable brush. The result can be most effective: a two-tone image, with normal blacks, greys and whites in the background, with a brown, blue, red, or green subject set against them. There are no set rules; the limitations are only in the boundaries of your imagination.

The application of a selenium toner, diluted $1:10$ rather than $1:3$, allows you to get the maximum brilliance from your print. It does take a little practice to acquire the skill, but when applied properly the overall appearance of your print will be enhanced to such an extent that you are unlikely to show an untoned picture again. What you require is: (1) A daylight-type filament lamp of about 200 watts positioned over or near the developing dish containing the toner. An ordinary lamp gives too warm an appearance and makes the progress of the toning difficult to judge. (2) A clean tray filled with toner to the appropriate dilution. (3) A control print in water nearby. (4) A tray filled with plain water. (5) A tray filled with fixer. You can tone a print which has been dried, or which has just been put through the processing stages in your darkroom. In either case, make sure the print is thoroughly washed (soak the dried print) in water, and then re-fix for about four minutes. Next, transfer it to the toner. Sometimes an intermediate wash is suggested between the fixing and the toner, but this can result in stains on the print.

Toning time is usually about five minutes. Start comparing with your control print from the two-minute mark. At this stage you will see the beginnings of a change in colour. The print will appear cooler, almost blue. As the time gets closer to the five-minute mark, the difference between the toned image and the control increases. The toned image will appear to be more brilliant and sharper, with richer blacks and cleaner highlights. When you are satisfied with the depth of the toning, rinse the toner off, then give the print a thorough wash; dry as normal. A print will tone to completion

sooner if it has predominantly mid-values. Where there are many lights and darks, the process takes longer. The five minutes advocated here is somewhere in the middle, and the job can take anywhere from three to six minutes.

The above method describes a slight toning, to change (for the better) the overall appearance of the print without actually changing the colour itself. When taken to the limit the colour does change and we get sepias, blues, etc. Among those types of toner available in kit form are: hypo-alum sepia toner for toning warm-tone papers to sepia; sulphide toner, for toning cold-tone papers to sepia; iron toning bath for blue tones; gold toner for reddish-brown tones on warm-tone papers; gold-thiocarbamide (thiourea) for bluish tones; selenium toner for purple to reddish tones; vanadium toner for green tones.

Most colour toners also intensify the image. In general, the first stage is to bleach the image, and in most cases the subsequent toning can be stopped at the appropriate point by lifting the print out of the toning bath and immersing it immediately in the wash water. Colour toning works best on prints containing a full range of rich tones, with good blacks. Prints that have undergone curtailed development do not in general tone well.

If the print to be toned has been dried, soak it first in water containing a little wetting agent, then immerse it in the bleach bath. Agitate continuously until bleaching appears to have been complete for about half a minute, then lift the print out of the bath, drain it, and rinse. Now immerse it in the toning bath, agitating continuously until the picture has acquired the right depth. At this point stop the toning (do not feel you have to leave the print in the toner for the full five minutes just because the instructions say so). Finally, wash and dry the print. For localised or partial toning, swab the area of the image you wish to tone with the bleach solution, until the area is fully bleached. Then, after rinsing, immerse the whole print in the toner. As the toner

will work only on the area that has been bleached, the remainder of the image will stay black and white. When the bleached image has reached the desired tone, wash and dry the print as before.

Toning is not confined to the colours so far mentioned. There are kits on the market which enable you to tone a print partially or completely in any desired colour, as well as dyeing the print (which colours the highlights but not the shadows).

Mounting

After all your work you will want to display your work at its best. Somehow, a naked print seems inadequate; it can be greatly enhanced in appearance by a suitable mount. You can mount a picture on anything you like: wood, hardboard, expanded polystyrene, fabric, and so on. For display purposes most amateur photographers use what is known as 'exhibition mounting board'. This is a heavyweight card cut to suit the format of the picture, with an appropriate area of white or colour surrounding it. The mount should be thought of as a part of the composition of the picture, and should be selected for size, shape and colour accordingly.

There are no hard and fast rules to govern the positioning of pictures on mounts. In general it is found that the most pleasing arrangement is where there is rather more space below the print than above it. However, some prints may look better with asymmetrical mounting, for example having borders which are much wider at the left and bottom edges than the others. Try it out; see how it looks, and decide whether you could live with it.

There are several methods of mounting. With fibre-based papers the most popular method is dry-mounting, and this can be done either with dry-mounting tissue or thermal mounting compound. Dry-mounting tissue is best used with a dry-mounting press, though at a pinch you can use a household iron; with thermal mounting compound a household iron is recommended. To

mount a print using tissue, position the tissue on the back of the print, and, using the tip of a domestic iron (or, better, a tacking iron sold for this purpose) tack the tissue to the print at several points near its centre. Now trim the print and tissue together. Next, position the print on the mount. When you are satisfied with its positioning, lift each corner of the print in turn and tack the tissue to the mount, being very careful not to shift the print. Cover the print with a sheet of print blotting-paper which has been in the press and is thoroughly dry, and load the sandwich into the press. Apply pressure for 2 to 3 minutes, then remove the mounted print. In general it should be firmly mounted. If, however, the mounting tissue is stuck to the print but not the mount, the press is too cold. Conversely, if the tissue is stuck to the mount but not the print, the press is too hot. Adjust the thermostat, wait a few minutes and try again. The same applies if you are using a household iron. Start with it set to 'synthetics' and turn up the thermostat if this setting is too cool.

Thermal mounting compound is painted on the back of the print with a brush and allowed to dry. Position the print on the mount, cover it with a piece of clean paper, and iron down, with the iron again set to 'synthetics' to begin with. Do not allow the iron to remain stationary at any position, as if you do the impression of its edges will be visible on the mounted print.

You cannot mount RC papers by heat. The base is polyethylene, which melts at the temperatures used for dry-mounting. Instead, use a special mountant obtainable in aerosol cans from photographic dealers. This type can be applied in one of two ways, depending on whether you want the mounting to be temporary or permanent. For a temporary mounting, simply spray the back of the print so that it is covered with a thin uniform layer of adhesive. Position the print on the mount, then press it onto the mount until it adheres firmly. If you want to remove the print at any time you can just peel it off.

For a more permanent fixture you have to work more carefully. Spray both the back of the print and the mount itself. Now, when the two surfaces come into contact the print is permanently fixed to the mount. Obviously, you must get the positioning right first time. When you have laid down the print, examine its surface carefully, and if there is any adhesive on the surface remove it carefully with a swab of cottonwool moistened with lighter fuel, or with an ordinary soft pencil eraser (the latter is less likely to remove any spotting you have done, but may leave marks if you are not careful). Lay a piece of clean white paper on the print and rub it down hard with the palm of your hand, or (better) with a roller squeegee, working from the centre outwards. Finally, remove any adhesive that may have strayed onto the mount beyond the limits of the print, using a pencil eraser. Your work is at last complete, and your beautiful picture is ready to exhibit, and earn the praise it deserves.

Pages 162–165 and 167 show the effects of different mounts, including different types of border and (in the final picture) asymmetrical mounting. *Manuel Torre* (page 162), *Michael Taylor* (page 163), *Neville Newman* (pages 164 and 167), *Michael Dobson* (page 165).

Index